LOOKING AT
PAINTINGS

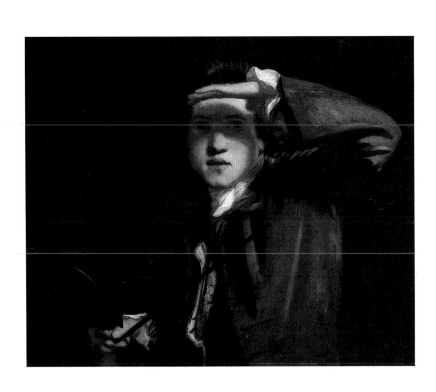

LOOKING AT
PAINTINGS

A GUIDE TO TECHNICAL TERMS

Dawson W. Carr and Mark Leonard

THE J. PAUL GETTY MUSEUM

in association with

BRITISH MUSEUM PRESS

© 1992 The J. Paul Getty Museum

Published by the
J. Paul Getty Museum
17985 Pacific Coast Highway
Malibu, California 90265-5799
in association with
British Museum Press
A division of British Museum
Publications Ltd
46 Bloomsbury Street, London
WC1B 3QQ

At the J. Paul Getty Museum:
Christopher Hudson, Head of Publications
Andrea P. A. Belloli, Consulting Editor
Cynthia Newman Helms, Managing Editor
Deenie Yudell, Design Manager
Karen Schmidt, Production Manager

Library of Congress Cataloging-in-Publication Data

Carr, Dawson W. (Dawson William), 1951–
 Looking at paintings : a guide to technical terms / Dawson W. Carr
and Mark Leonard.
 p. cm.
 Includes bibliographical references.
 ISBN 0-89236-213-8
 1. Painting—Dictionaries. I. Leonard, Mark, 1954–
II. Title.
ND31.c37 1992
750'.3—dc20 91-24329
 CIP

British Library Cataloguing in Publication Data

Carr, Dawson W. (Dawson William), 1951–
Looking at paintings : a guide to technical terms.
I. Title II. Leonard, Mark, 1954–
751.4

ISBN 0-7141-1725-0

Cover: Dieric Bouts (Flemish, active c. 1445–1475). *The Annunciation*,
c. 1450/55 (detail). Glue tempera on canvas, 90×74.5 cm (35⁷⁄₁₆×29⅜
in.). JPGM, 85.PA.24. (See entry for CANVAS.)

Frontispiece: Sir Joshua Reynolds (British, 1723–1792). *Self-Portrait*,
c. 1747. Oil on canvas, 63.5×74.3 cm (25×29¼ in.). London, National
Portrait Gallery, 41.

Foreword

This book is intended as a guide for the museum visitor who wishes to know more about the materials and techniques of paintings, as well as the terminology used to describe their visual effects. Curators and conservators often fail to realize that many museum visitors are not familiar with the language of their somewhat rarefied professions, including many terms derived from foreign languages; this book will aid museum-goers who want to understand more fully the information presented in catalogues or on wall labels.

Owing to the confines of space, the terms included in this glossary are limited to those that are primarily technical in nature and thus are essential to discussions of the physical appearance of a painting. Terms that apply to broader, interpretative aspects of works of art (such as schools or styles of painting) are necessarily omitted. While this book includes paintings of the twentieth century, a much longer volume would be required to do justice to the myriad of materials and techniques that have been introduced since 1900.

Some of the terms in this book may also be found in the other *Guides to Technical Terms* published in this series. The term *watercolor*, for example, is defined in the volume that deals with prints, drawings, and watercolors; the term is also applicable to paintings, so it has been included in the present volume as well.

We are indebted to Andrea P. A. Belloli of Getty Trust Publications for her guidance and advice in the development of the original list of terms and to John Harris for his editing of the manuscript. Mary Vernon (Chairman of the Department of Fine Arts, Southern Methodist University, Dallas), Joseph Fronek (Conservator of Paintings at the Los Angeles County Museum of Art), and Lindsay Stainton (Assistant Keeper of Prints and Drawings at the British Museum) provided many insightful comments. We have also benefited from the support and constructive comments provided by the Paintings and Paintings Conservation departments at the Getty Museum.

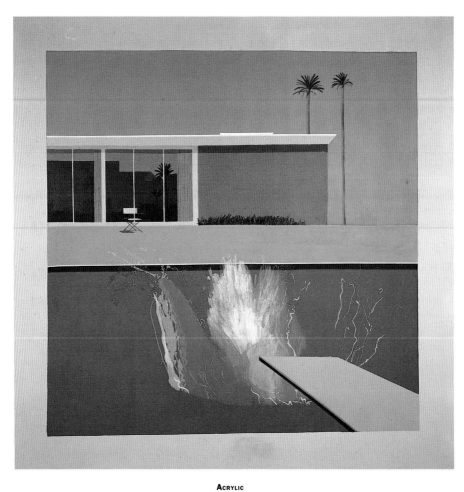

ACRYLIC
David Hockney (British, b. 1937). *A Bigger Splash*, 1967.
Acrylic on canvas, 243.8×243.8 cm (96×96 in.). London, Tate Gallery. Photo: Art Resource, N.Y.

ACADEMIC

This adjective may refer to art, artists, or ideas influenced or formed by the principles of one of the academies established since the beginning of the sixteenth century. These principles include drawing from the model, studying favored art of the past (especially the antique), using drawings to prepare for painting, and applying theoretical rules of design (which have varied with the sanctioned style of the time). Academies were also responsible for establishing a strict hierarchy of types of painting. History painting—or pictures with lofty subjects from biblical, mythological, or historical sources—was always held in the highest regard. Portraiture followed, with landscape, still life, and genre painting near the bottom of the list. *Academic* is widely employed today to characterize work lacking originality. The use of this word in a pejorative sense began in the late nineteenth century, when artists rebelled against the idea that art could be made and governed by a set of rules.

ACRYLIC

In its truest sense, the term *acrylic* refers to a group of synthetic polymers manufactured from compounds containing an acrylic acid group in their chemical structure. However, the term has come to include a variety of synthetic materials, many of which have been used as substitutes for OIL-based paints.

Acrylic paints are commonly manufactured in an emulsified form, which means that the synthetic resin is suspended as tiny drops in water (the resultant mixture is called an EMULSION). For this reason, the paints can be diluted with water. Once the paint has been applied to a surface, the water evaporates, leaving behind the synthetic resin (and PIGMENT), which is no longer water soluble. The water-based nature of acrylic paints allows for easy application and rapid drying time: acrylic paints dry in a matter of minutes, as opposed to the many months required for oil-based paints.

Acrylic paints were introduced as early as 1936, but they did

Note Words printed in SMALL CAPITALS refer to other entries in the book.

not become widely used until later. Visually, acrylic-based paints can appear to be very similar to oil-based paints, but they cannot rival the rich, translucent nature of oils.

AERIAL PERSPECTIVE See PERSPECTIVE.

AFTER See ATTRIBUTION.

ALLA PRIMA An Italian term meaning "at first," used to describe a method of OIL painting in which the final effect is achieved in a single, direct application of paint to a GROUND. In contrast to layering the paint with UNDERPAINTING and GLAZING, this technique challenges the painter to create effects of ILLUSIONISM with the greatest economy of means, often emphasizing eloquent BRUSHWORK. Not necessarily an independent technique, it is often used adjacent to areas with a complex layering of paint. While this type of painting was initiated in the sixteenth century, it was not practiced widely until the middle of the nineteenth century, when painters sought to create the impression of immediacy in their works. The synonymous French term *au premier coup* is more precisely applied to paintings of this period, while the term *direct painting* describes the spontaneous techniques of twentieth-century painters.

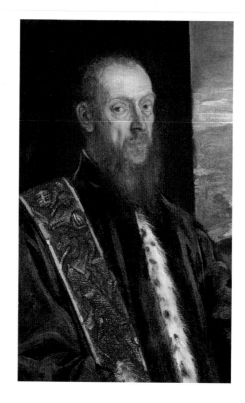

ALLA PRIMA
Jacopo Tintoretto (Italian, 1518–1594). *Portrait of Vincenzo Morosini*, c. 1585. Oil on canvas, 84.5 × 51.5 cm (33¼ × 20⅜ in.). NGL, 4004.

The folds of the robe and much of the landscape at right are painted *alla prima*.

ASCRIBED TO	See ATTRIBUTION.
ATMOSPHERIC PERSPECTIVE	See PERSPECTIVE.
ATTRIBUTE	An object traditionally used by artists to identify a person, office, or concept. As portraitists sometimes depict sitters with the tools of their trade, mythological and allegorical figures as well as saints are often identifiable by symbols long associated with their powers, dominions, or martyrdoms. In order to insure comprehension, the complex language of attributes has been somewhat standardized in manuals compiled and printed beginning in the sixteenth century.

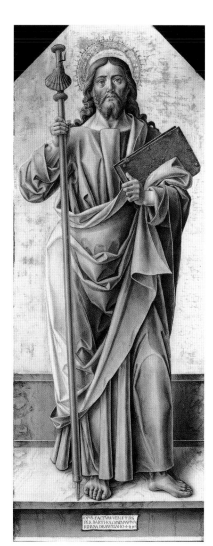

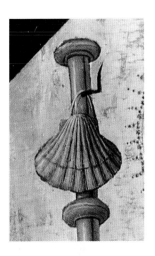

ATTRIBUTE

Bartolomeo Vivarini (Italian, c. 1432–1499). *Saint James the Greater*, 1490. Tempera on panel, 144×56 cm (56¾×22 in.). Central panel from a polyptych. JPGM, 71.PB.30.

The attributes of Saint James the Greater are the pilgrim's staff and the scallop shell (seen in the detail) derived from the distinctive badge worn by pilgrims to the saint's shrine at Santiago de Compostela in Spain.

ATTRIBUTION

The assignment of a painting of uncertain authorship to a particular artist, to his or her followers, or to an unknown artist. (In the latter case, the so-called "school of" a painting is usually specified, such as "Venetian, sixteenth century.") Employing CONNOISSEUR-SHIP, art historians and critics make attributions by comparing stylistic traits in unattributed paintings to those found in works securely assigned to an individual or characteristic of a certain place at a certain time. External evidence from contemporary descriptions, contracts, and inventories can also be employed. Even with well-known artists, attribution can be highly subjective, and experts often disagree and change their minds. Opinions as to the authenticity of a painting can also be controversial because of their effect on the work's monetary value.

The terminology used in connection with attribution is hardly exact but generally follows a pattern of diminishing contact with the artist. A painting is called *autograph* when it is thought to be entirely the work of an artist. *Attributed to* signifies less certainty that the work is wholly by the individual. Virtually synonymous, *ascribed to* sometimes implies a slightly greater degree of doubt or an old attribution used for the sake of convenience. *Studio of* or *workshop of* is used with paintings made by an unknown assistant or assistants in the artist's shop, perhaps under the artist's direct supervision. *Circle of* and *style of* designate an unknown hand influenced by the artist and working in about the same period, while *follower of* and *manner of* usually indicate a later date. *After* generally indicates a copy of a known work made at any date. See also ORIGINAL.

AU PREMIER COUP

See ALLA PRIMA.

AUTOGRAPH

See ATTRIBUTION.

AUTOGRAPH COPY

See ORIGINAL.

AUTOGRAPH REPLICA

See ORIGINAL.

BITUMEN

Sometimes referred to as asphaltum, bitumen is a naturally occurring tar-like substance that produces a deep, warm, brown-black color. It has been used since ancient times and can be found in the GROUNDS and paint films of European and American paintings of many periods, although its usage is most commonly associated with English painters of the eighteenth century.

Bitumen is mixed with linseed OIL in order to create a painting material. Unfortunately, bituminous paint films rarely dry properly; when bitumen is used as an UNDERPAINT, a faster-drying

paint applied on top of the slower-drying bitumen will literally slide across the surface of the wet bituminous layer as it dries, resulting in the development of large shrinkage cracks (see CRAQUELURE). Paintings that contain bitumen are also easily damaged during cleaning (see CONSERVATION) as a result of the soft, soluble nature of the material.

BODY COLOR

When associated with prints, drawings, or WATERCOLORS, the term *body color* refers to a water-based, opaque painting MEDIUM (such as GOUACHE or TEMPERA). However, in broader usage, body color can refer to a PIGMENT that is naturally opaque (such as opaque chromium-oxide green), as opposed to one that is naturally transparent (such as transparent chromium-oxide green, called viridian). Body colors can be used as opaque MIDDLE TONES when creating the illusion of form; shadows are added with transparent darker GLAZES, highlights created with opaque lighter SCUMBLES.

BOLE

A clay material that is used as the preparatory layer for application of very thin layers of gold or silver (called leaf). Bole is prepared by mixing colored clay with a water-based adhesive (such as rabbit-skin glue). Although traditional boles are usually dark red in color, many variations can be found, ranging from white to light yellow to deep violet. Because metal leaf is very thin, the color of the bole has a substantial effect upon the appearance of the GILDING. In pictures that have suffered from cracks or abrasions in gilt areas, the bole can often be seen in areas where the metal leaf is missing.

In classic water-gilding, the bole mixture is applied to the area to be gilded and allowed to dry. A smooth piece of agate may be used to burnish the surface of the colored clay. The bole is then re-wetted in order to activate the adhesive, and the metal leaf is applied.

BOZZETTO

See OIL SKETCH.

BRUSH

The basic tool used to apply not only paint but VARNISHES and metal leaf as well. Brushes are made from a wide variety of materials and come in a nearly infinite array of shapes and sizes. In ancient times, brushes may have been made from tufts of animal hair tied in small bundles to a reed handle. Cennino Cennini, writing in the fifteenth century, described delicate brushes made from miniver fur and mounted on quill handles, as well as larger brushes made from hog hairs and attached to wooden sticks. In

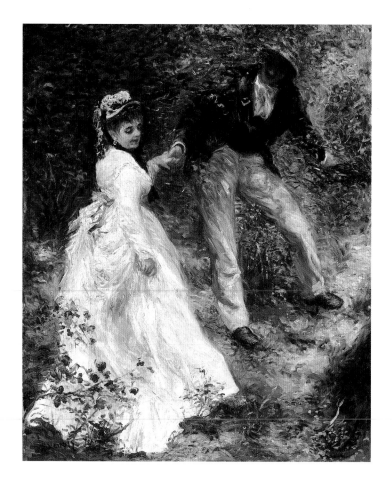

the nineteenth century, metal ferrules were introduced as a means
of holding the brush hairs together. The size and shape of the
ferrule were dictated by the desired size (wide or narrow) and
shape (flat or round) of the brush. In modern times, brushes of
the highest quality are most frequently made with sable hair.
Coarser animal hairs are still used to make bristle brushes, and a
number of synthetic fibers have been introduced.

BRUSHWORK

Brushwork consists of textures and impressions within a painting
created by the workings of the artist's BRUSH. Because it is, in
essence, a direct reflection of the pressure and movement of the
artist's hand across the surface of the painting, brushwork is
one of the most intimate links that we, as viewers, have with the
artist's mind at work.

Brushwork can be as varied as the types of brushes used to
create a painting. Characterizations of brushstrokes include such

Renoir's vibrant brushwork captures the impression of light falling across the surfaces of the figures.

divergent descriptive terms as broad and fluid (sometimes referred to as painterly) or tight and controlled. Brushwork may not even be immediately apparent: in early Italian egg-TEMPERA paintings, for example, the fact that the image is composed of a pattern of overlapping short brushstrokes only becomes apparent upon very close inspection.

The term *stippling* refers to the technique of making repeated applications of paint by holding a stiff brush directly perpendicular to the surface of the painting.

CANVAS

This term literally refers to a piece of cloth woven from flax, hemp, or cotton fibers. However, the word has generally come to refer to any piece of fabric used as a SUPPORT for painting.

Use of canvas supports can be traced back to ancient times, but our traditional understanding of its development stems from the practice in early Italian Renaissance painting of gluing a piece of linen to a wooden PANEL prior to application of a GESSO

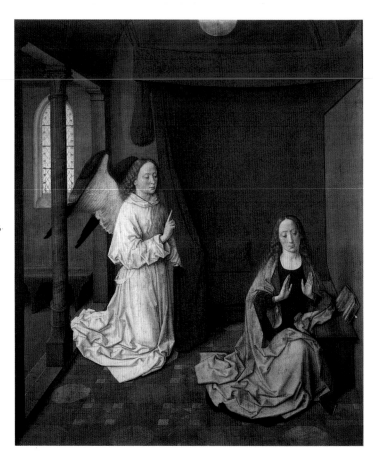

CANVAS
Dieric Bouts (Flemish, active c. 1445–d. 1475).
The Annunciation, c. 1450/55.
Glue tempera on canvas, 90 × 74.5 cm
(35⁷⁄₁₆ × 29⅜ in.).
JPGM, 85.PA.24.

GROUND. Variations on this practice included stretching the fabric loosely across the panel support and, eventually, supporting the canvas only at the edges with an assembly of strips of wood (called a strainer).

In Venice, painting on canvas gained favor as a substitute for FRESCO. Wall paintings did not survive well in the wet Venetian environment; canvas was used as a stable and economical means of covering large areas of wall space with painted decorations.

Early canvas paintings were also developed for use as banners or processional pieces. The light fabric support provided a practical alternative to heavy and cumbersome large wooden

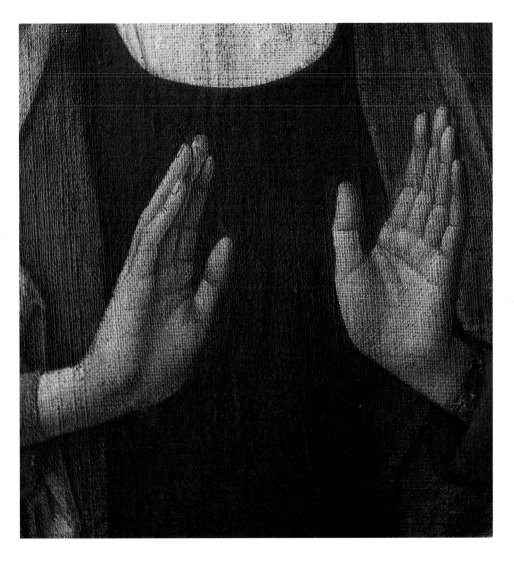

In this detail, the weave of the fabric SUPPORT is clearly visible on the surface of this early canvas painting.

panels. Large canvas paintings could also be used in place of more costly tapestry decorations in decorative schemes.

Northern European painters of the fifteenth century became masters of the type of canvas painting commonly referred to as Tüchlein. Fabric supports eventually came to be accepted for use in oil paintings as well.

Canvas can range in texture and weight from very fine (similar to handkerchief linen) to very coarse (such as burlap). The character and pattern of the canvas are usually visible on the surface of the painting. Although most canvas paintings are executed on a plain weave fabric, unusual patterns (such as herringbone or twill) can also be found.

Cartoon

A full-scale drawing or painting used in the transfer of a design to an easel painting, FRESCO, tapestry, stained glass, or other work, usually of large size. The term derives from *cartone*, the Italian word for the heavy paper on which cartoons were made. They were usually executed with chalk or charcoal and sometimes were fully colored in WATERCOLOR, GOAUCHE, TEMPERA, or OIL. For frescoes, cartoons were laid on the wet plaster, and each day's work was transferred by POUNCING or by INCISING the design

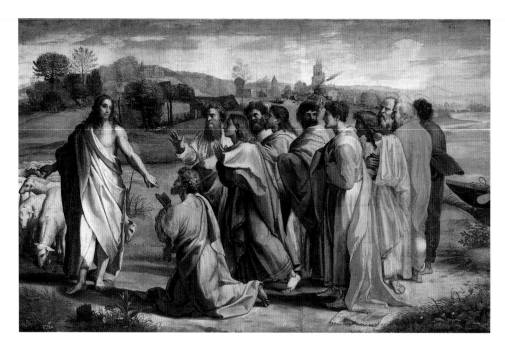

Cartoon
Raphael (Raffaello Sanzio [Italian, 1483–1520]). *Cartoon for the Tapestry of the Charge to Peter*, c. 1515/16. Gouache on paper, 343×532 cm (135×209½ in.). By courtesy of the Board of Trustees of the Victoria and Albert Museum.

through the cartoon with a stylus. The word *cartoon* gained its contemporary meaning as a humorous drawing or parody when the designs for the murals in the British Houses of Parliament were satirized in *Punch* in 1843.

CASEIN

An adhesive made from the curd of soured skim milk. Although casein powder mixed with limewater has been used as a binder for PIGMENTS since ancient times, only scattered references to the use of casein in old master paintings can be found. During the nineteenth century, casein colors gained some popularity and were commercially manufactured. The surface of a casein painting has a dull matte sheen.

Casein is considered to be a difficult medium that presents problems in handling and correction (primarily because of its quick-drying nature); it also forms an extremely brittle film that does not age well.

CASSONE PAINTING

A painted panel inset in an Italian marriage chest, but today often displayed detached and framed like an easel painting. Sometimes the biblical or mythological episodes depicted in these paintings celebrate marriage, but battle scenes were also produced in great numbers. Particularly popular in fifteenth-century Florence, this type of furniture decoration was usually executed by specialists who seldom produced paintings of high quality, but occasionally *cassoni* were painted by great artists.

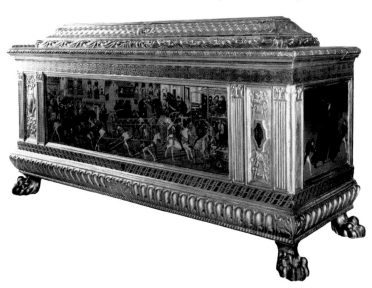

CASSONE PAINTING
Florentine school, fifteenth century.
Cassone with a Tournament Scene. Carved, gilded, and painted wood.
Main panel 38.1 × 130.2 cm (15 × 51¼ in.).
NGL, 4906.

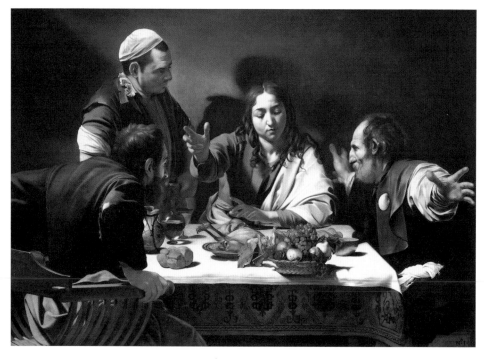

CHIAROSCURO
Michelangelo Merisi da Caravaggio (Italian, 1573–1610).
The Supper at Emmaus, c. 1600. Oil on canvas, 141 × 196.2 cm (55½ × 77¼ in.). NGL, 172.

CHIAROSCURO

The Italian words *chiaro* (light) and *oscuro* (dark) are conjoined to describe the effects of light and shadow in painting, particularly when the contrast between the two is very pronounced. The term is most often associated with the lighting found in the paintings of Caravaggio and his followers, and of Rembrandt. This dramatic illumination is often characterized by a shaft of light like that produced by a spotlight, which results in strong highlights and sharply cast shadows. Compare SFUMATO.

CIRCLE OF

See ATTRIBUTION.

COLOR

White light (such as sunlight) contains all the different wavelengths of light that are seen as color; a prism can be used to separate white light into the familiar rainbow spectrum. Individual colors are perceived by the eye (and the mind) when specific wavelengths of light are reflected off a surface. A blue pigment, for example, will absorb all wavelengths of light except for those in the blue range, which are reflected for us to see.

Colors are characterized by three attributes: hue or tint (which refers to the common name of the color, such as red or green), value or tone (which defines the relative lightness or darkness of

the color, corresponding to a gray scale that ranges from white to black), and intensity (which describes the degree of saturation of the color: a pale blue is considered to be less intense than a deep, rich blue, for example).

The synonymous terms *half-tone* and *middle tone* are used to describe a color that falls somewhere between the lightest, least intense, and the darkest, most saturated appearance of a particular hue. In painting, half-tones are usually found in the part of the form (as in a piece of drapery or a flesh tone) that lies between the highlight and shadow. In this way, color is used to create the illusion of three-dimensional form.

Artists become familiar very early in their training with the basic color-mixing rules. The primary colors are red, yellow, and blue. The secondary colors of orange, green, and violet are achieved by mixing the primary colors in various combinations (yellow mixed with blue produces green, for example). Warm colors contain more red tones and cool colors contain more blue tones. Complementary colors are considered to be in extreme contrast to one another (such as red and green, which, when placed side by side, intensify one another's appearance and, when mixed together, produce gray). The illusion of iridescent shot fabrics (which appear in many paintings) stems from the use of complementary colors in the highlights and shadows of a drapery.

Color theory has played an important role in the history of art. Most color theories represent attempts to classify or systematize the way in which the eye sees color and provide the artist or viewer with a series of aesthetic guidelines.

CONNOISSEURSHIP

The method of ATTRIBUTION that uses visual evidence alone to identify the specific author of a work of art or its time and place of execution. With an in-depth knowledge of period and individual styles, the connoisseur evaluates a work of unknown authorship by comparing its visual characteristics with those of other works known to her or to him. Equally important is the ability, formed through years of study of original works, to discern quality or the relative aesthetic merits of a given object.

CONSERVATION

The restoration and preservation of works of art. Paintings are composed of inherently unstable materials that undergo complex changes as they age and interact with their environment. Changes occur as the result of natural aging (such as the fading of FUGITIVE PIGMENTS or the development of CRAQUELURE) or from interference from a host of outside factors (including such damage as

tears and holes). Any change in the appearance of the materials used in a painting alters the appearance of the entire work of art and, ultimately, affects our perception of both the artist's and the work's meaning and intent. During the processes of restoration and preservation, conservators must be able to combine their knowledge of painting materials with their deeper understanding of the particular work in order to present and preserve for the future a work of art that still has significance as a unified whole.

Problems within paintings that require repair and restoration are diverse and complex. VARNISH coatings discolor with time and must be removed or replaced; structural weaknesses develop in SUPPORTS and must be stabilized and reinforced; and lost or damaged areas in the painting must be reconstructed through RETOUCHING. Such treatments are complicated by the ethical demands of modern conservation, which dictate not only that any alterations or additions to a painting must be completely reversible, but that the hand of the restorer must remain invisible as well.

Preservation of paintings has been greatly enhanced in this century by the advent of improved methods of climate control. Stable levels of temperature and humidity can be provided, and light sources can be filtered and controlled in order to create ideal environments. Such controls, linked with the use of increasingly stable restoration materials, can do much to enhance the preservation of paintings.

COPPER

Although not as common as wood or CANVAS, copper has also been used since ancient times as a SUPPORT for painting. Copper could be hammered by hand into a thin sheet; this method produced a characteristically uneven surface, which was preferred by some artists. Techniques for rolling the metal into thin plates were introduced in the middle of the sixteenth century.

The natural deep reddish brown of a copper plate was often favored by artists for use as a GROUND color.

Paintings executed on copper tend to have an enamel-like surface as a result of the smoothness of the support. Copper does not respond as quickly as wood or canvas to changes in temperature and humidity, and, as a result, copper paintings are often beautifully preserved.

COPY

See ORIGINAL.

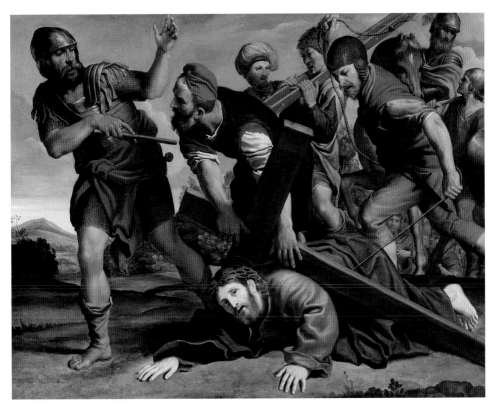

COPPER

Domenichino (Domenico Zampieri [Italian, 1581–1641]). *Christ Carrying the Cross*, c. 1610.
Oil on copper, 53.7 × 67.7 cm (21 1/8 × 26 5/8 in.). JPGM, 83.PC.373.
The surface of this copper SUPPORT was covered with a tin plating prior to execution of the painting.

CRADLE

A wooden framework attached to the reverse of a PANEL painting, which, in theory, is designed to prevent warping or splitting of the SUPPORT.

The concept of cradling may have developed from the practice of early Italian panelmakers of placing wooden supporting battens in shallow channeled grooves on the reverse of panels, running perpendicularly to the grain of the wood. The modern cradle, which was developed during the nineteenth century, is a more complex assembly of interlocking supports: strips of wood running parallel to the grain are glued to the panel in a fixed position; wooden strips aligned perpendicularly to the grain are held in place by the fixed bars but are free to move with the natural expansion and contraction of the panel as it responds to changes in temperature and humidity. Prior to application of a cradle, the reverse of the original panel is often planed to create an even surface.

Unfortunately, cradles can become locked in place over time

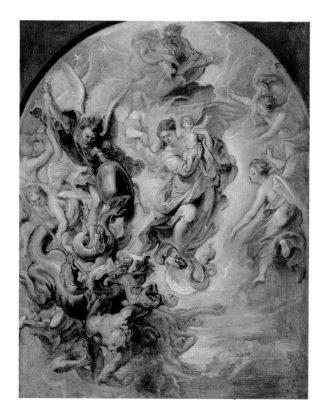

CRADLE
Peter Paul Rubens
(Flemish, 1577–1640).
*The Virgin as the Woman
of the Apocalypse*, 1623–24.
Oil on panel,
64.5 × 49.8 cm
(25⅜ × 19⅝ in.).
JPGM, 85.PB.146.

and may actually promote the kinds of problems (such as splits) that they were designed to prevent. The massive nature of many cradles can also significantly alter the basic character of a painting; if the original panel is thinned to an excessive degree, the impression of the cradle can be transferred to the surface of the painting, creating an unsightly washboard effect.

In recent years, cradling has fallen out of use in favor of less invasive, more sympathetic techniques for treating structural problems in wooden supports.

CRAQUELURE

A pattern of cracks that develops on the surface of a painting as a result of the natural drying and aging of the paint film. The use of different types of paint media and painting SUPPORTS will result in varying types of craquelure. TEMPERA paintings, for example, will develop a characteristically delicate craquelure, which in some cases may be so fine as to be nearly invisible to the naked eye. OIL paintings, on the other hand, tend to develop a more prominent network of drying cracks; the pattern will vary according to the type of support used, as well as the type of environmental conditions to which the painting has been exposed.

A cradle was applied to the back of Rubens's painting during the nineteenth century.

The cradle was removed in order to repair some splits in the panel, and a pair of light support braces was used in place of the heavier cradle.

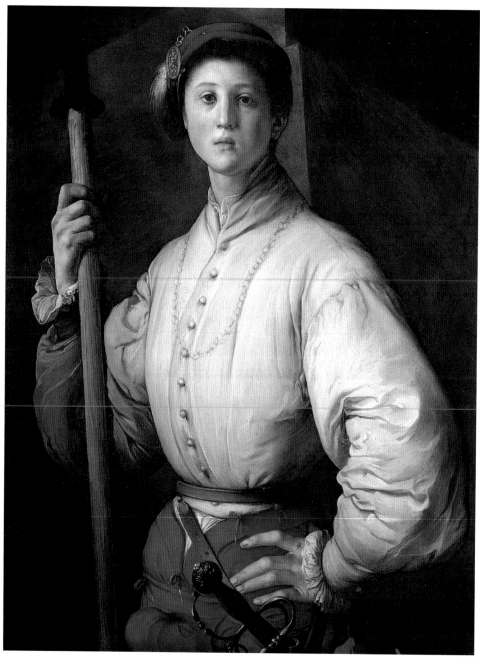

CRAQUELURE

Pontormo (Jacopo Carucci [Italian, 1494–1557]). *Portrait of Cosimo I de' Medici*, c. 1537. Oil and tempera on panel transferred to canvas, 94.9×73 cm (37⅜×28¾ in.). JPGM, 89.PA.49.

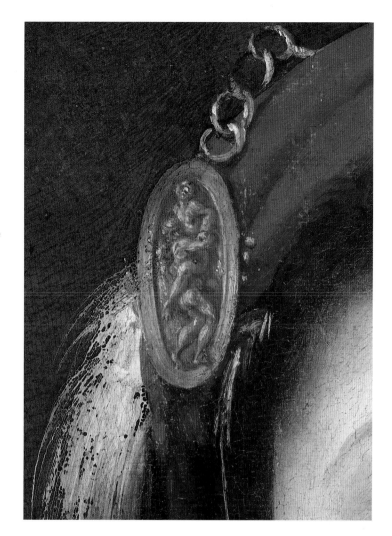

The very fine craquelure is a result of the natural aging of the paint. The figure of Hercules overcoming Antaeus is depicted on the young prince's hat badge.

If significant amounts of resins or other complex materials are mixed with the paint, large, disfiguring drying cracks may develop, imparting a texture to the surface of the painting that resembles reptile skin (hence the term *alligator cracks*). A circular pattern of impact cracks can develop in a canvas painting as the result of a foreign object striking the surface or the reverse of the painting.

Craquelure is considered a natural and, to some extent, desirable phenomenon. Drying cracks do not necessarily indicate that the paint has loosened from the support. Although the visual prominence of excessive crackle patterns can be minimized with RETOUCHING, the presence of most craquelure should simply be accepted.

DEAD COLORING See UNDERPAINTING.

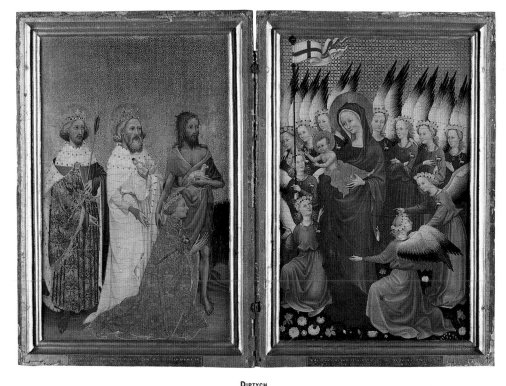

DIPTYCH
Unknown artist of the French(?) School.
"The Wilton Diptych": King Richard II of England Commended by His Patron Saints to the Virgin and Child,
c. 1395 or later. Tempera on panels, each wing 46×29 cm (18⅛×11⅜ in.). NGL, 4451.

DIPTYCH

A picture comprising two panels or leaves, usually hinged together so that they can be closed like a book. Diptychs were most often made on a small scale for portable devotional use. In one typical arrangement, one panel would contain a portrait of the owner praying to the Virgin and/or Christ, who would be represented on the other panel. The backs of the panels were also decorated, sometimes imitating precious stone or bearing the coat of arms of the owner. See also TRIPTYCH and POLYPTYCH.

DIRECT PAINTING

See ALLA PRIMA.

DISTEMPER

See TEMPERA.

EGG TEMPERA

See TEMPERA.

EMULSION

A mixture of two materials that do not naturally mix (such as oil and water). In order to create a paint MEDIUM, an emulsifying agent is introduced to a mixture of resin (or oil) and water, thus allowing tiny droplets of the resinous material to remain sus-

pended in the water. When the water evaporates, the resinous material left behind forms the now non-water-soluble film of paint.

Egg yolks are naturally occurring emulsions. Emulsions of egg and oil may have been used as painting media as early as the sixteenth century. In the twentieth century, synthetic polymer emulsions of man-made resins and water have been introduced as alternatives to oil paints. See also ACRYLIC.

ENCAUSTIC

A wax-based paint. Encaustic paintings are created by mixing PIGMENT with molten wax (such as beeswax) and applying the

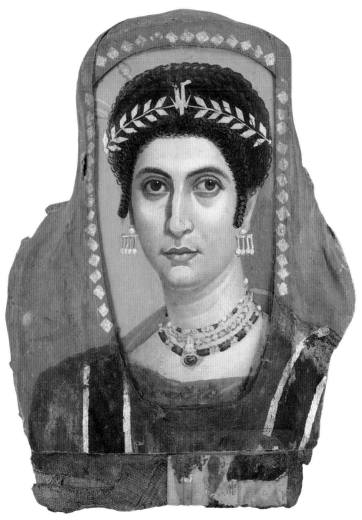

ENCAUSTIC
Egyptian (Fayum district). *Portrait of a Woman*, c. 100–125. Encaustic and gold leaf on panel, 33.6 × 17.2 cm (13¼ × 6¾ in.). JPGM, 81.AP.42.

mixture to a SUPPORT while still hot. After the colors have been completely applied, the entire picture is heated slightly in order to fuse the paint layers together.

Encaustic is most commonly associated with Egyptian portraits on mummy cases of the second to fourth centuries A.D.; these are known as Fayum portraits because of their common occurrence in the Fayum district of upper Egypt. The extreme stability of the encaustic medium has allowed Fayum portraits to remain exceptionally well preserved, possessing an astonishing clarity.

Encaustic was rarely used again as a paint medium until the early twentieth century, when some artists developed an interest in the fact that encaustic could be used to create thick, vibrant IMPASTO with an opaque, matte surface (as opposed to the glossy surfaces of OIL paints).

ENGAGED FRAME See FRAME.

FAKES AND FORGERIES Objects that simulate the appearance of genuine works of art but were made with a deliberate intent to deceive. The creation of a forgery is usually motivated by financial gain.

When creating a painting that purports to be a work from an earlier period, a forger will often unwittingly produce stylistic or technical anomalies from his or her own time. Conversely, when creating a pastiche a painter intentionally imitates the work of a particular artist or artistic style by copying a number of elements from a variety of original paintings and recombining them in a single work. Unlike a forgery, a pastiche is not necessarily intended to deceive.

As the value of particular works of art increases, so does the incentive for forgers. At the end of the nineteenth century, for example, there was a great resurgence of interest in early Italian Renaissance paintings; a high demand for such pictures by museums and private collectors inflated their value, and a perfect atmosphere was established for the sale of forgeries. Skilled craftsmen created very clever fakes of Italian "primitives," occasionally using old pieces of wood (obtained from antique furniture) as a basis for their paintings. After completion, the pictures were aged by overexposure to the elements, such as baking in direct sunlight for a period of several months. The forgeries could also be "damaged" and subsequently "restored" as a means of enhancing the aged character of their surfaces.

With the advent of scientific analysis of works of art in the first half of the twentieth century, the ability to identify fakes and forgeries was vastly improved. Technical investigations of genuine works of art increased the understanding of the types of materials

used by artists during particular periods. If a painting were suspected of being a forgery, established technical knowledge could then be used as a basis for comparative analysis; if the materials in the suspected fake were found to be inconsistent with materials known to have been used in genuine works of art during a particular period, the evidence against the painting was enhanced. PIGMENT analysis has become particularly useful in this respect. Zinc white, for example, a common pigment used extensively during the nineteenth century, was not available as an artist's material prior to the 1830s. Its appearance, therefore, in a painting purporting to be from an earlier time (such as the fifteenth century, the time of the early Italian Renaissance) would support the conclusion that the painting was a later forgery.

Of course, information concerning the use of particular pigments and materials is now as available to a potential forger as it is to an art historian. Fortunately, conservation scientists have continued to develop increasingly sophisticated and subtle analytical techniques to aid in the detection of forgeries. Tools such as the scanning electron microscope can be used to identify characteristics of the original sources or manufacturing processes of particular pigments; trace-element analysis and carbon-14 dating can be carried out on increasingly smaller samples, allowing for the use of such analytical methods as fairly reliable dating techniques on paintings. Today, it seems unlikely that a forger could produce a work of art without some sort of technical anomaly.

Although scientific tools of investigation provide invaluable analytical information, it is essential to realize that "proving" or "disproving" the authenticity of a work of art is virtually impossible; scientific evidence can support a particular conclusion but is always subject to interpretation and comparison. In the end, we must all return to our dependence on the eye, which is the most reliable tool of all for telling us about a work of art.

FECIT	See SIGNATURE.
FOLLOWER OF	See ATTRIBUTION.
FORESHORTENING	The technique of depicting an object or figure so that it appears to recede. Forms lying at an angle to the PICTURE PLANE are proportionately compressed to obtain the illusion of their extension in space. (Illustration on next page.) This term is applied to individual things or their parts as opposed to PERSPECTIVE, which refers to the overall construction of space. See also SOTTO IN SÙ.

FORESHORTENING

Nicolas Poussin (French, 1594?–1665). *The Sacrament of Holy Eucharist*, 1647. Oil on canvas, 117.5 × 177 cm
(46¼ × 69½ in.). Duke of Sutherland Collection, on loan to the National Gallery of Scotland.
The figure in the center foreground is an example of extreme foreshortening.

FRAME

A border around a picture added to enhance its appearance by
isolating it from its surroundings or by linking it to the decor.
Decorative borders are quite ancient, but frames as we know them
originally served a protective or structural function around reli-
gious images that were handled or set in large architectural altar-
pieces. Frames are most often made of wood but may be painted
in TROMPE L'OEIL at the edge of CANVASES or around FRESCOES. In
the nineteenth century, molded plaster frames became common
and were usually GILDED like their carved wood counterparts.

An engaged frame is fashioned from the same piece of wood
as a PANEL painting and remains an integral part of it. Created by
the painter or to the painter's specifications, such engaged frames
sometimes used ILLUSIONISM to connect the frame and the image
or carried an inscription related to the meaning of the work.

Except for engaged frames, it is often difficult to establish that
a frame is original to a painting, even if it is contemporary,
unless there is specific documentation. Paintings have often been
reframed according to the individual tastes of owners, usually
in more modern styles. Whenever possible, museums try to find
frames from the same period and culture as the paintings they

enhance, although sometimes a frame from a distant time and place can be used to show a painting to excellent effect.

FRESCO

The Italian word for "fresh" is used for the technique of wall painting in which PIGMENTS mixed in water (or limewater) are applied directly onto freshly laid lime plaster; also a MURAL painted in this way. This method, called *buon fresco* or true fresco, is extraordinarily permanent in dry climates because the colors penetrate into the plaster and become an integral part of the wall as it dries. Thus, the technique was favored for all major wall paintings in central Italy but was little used in Northern Europe, where damp would quickly cause the plaster to crumble. Fresco is particularly valued for the bright luminosity of its colors, which retain their original brilliance to an exceptional degree.

The wall is prepared by laying on a rough coat of lime and sand called the *arriccio*. Then a coat of fine plaster called the *intonaco* is laid on and the paint applied. Only enough intonaco for one day's work is prepared because plaster dries overnight. Each section of intonaco is called a *giornata* (day), and it is possible to determine the time taken to complete the fresco by counting these sections. Fresco is a demanding technique because of the speed of execution required and because it is virtually impossible

to correct work without removing the plaster and starting again.
Only an experienced fresco painter can know the final effect,
because wet colors look quite different after they have dried.

Early artists often painted their designs onto the arriccio with
sinopia, a reddish brown chalk mixed in limewater. This type of
drawing, also called sinopia, has been recovered from frescoes
detached from their original wall for reasons of preservation.
Later, artists used CARTOONS to transfer their designs to the
intonaco by POUNCING or INCISING. *Fresco secco*, or painting onto
dry (*secco*) plaster, approximates the effect of true fresco but is
susceptible to flaking. Sometimes whole works were painted in this
technique, but it was also commonly used by painters RETOUCHING
true frescoes; unfortunately, these details in fresco secco are
often lost owing to their fragility. *Mezzo fresco* or half-fresco
involved painting onto partially dried plaster, a technique common
from the mid-sixteenth century. By the end of the eighteenth
century, the use of fresco was more the exception than the rule.
The technique was revived (and revised) in the nineteenth century,

particularly by the Viennese group known as the Nazarenes; the greatest twentieth-century exponents have been Mexican muralists.

FUGITIVE PIGMENT

A PIGMENT that is particularly susceptible to fading over time. The fading process is actually a chemical change initiated by exposure to light. Pigments that bear a similarity to organic dyes are often fugitive in nature; the original color may be quite intense but will fade quickly. In Northern European still-life paintings of the seventeenth century, for example, an intense yellow pigment (known as "yellow lake") was commonly mixed with a blue pigment in order to create the visual effect of green leaves. Over time, the yellow lake has faded, resulting in the illusion of blue leaves.

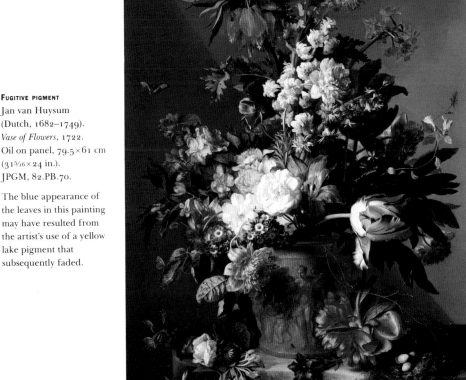

FUGITIVE PIGMENT
Jan van Huysum
(Dutch, 1682–1749).
Vase of Flowers, 1722.
Oil on panel, 79.5 × 61 cm
(31 5⁄16 × 24 in.).
JPGM, 82.PB.70.

The blue appearance of the leaves in this painting may have resulted from the artist's use of a yellow lake pigment that subsequently faded.

GESSO

In the strictest sense, the Italian word *gesso* refers to a mixture of calcium sulphate (a white powder commonly known as gypsum) and rabbit-skin glue that is applied in liquid form as a primer to the surface of a painting SUPPORT. In broader usage, the term has come to refer to many types of similar white preparatory layers, including those made from chalk (calcium carbonate), as well as modern synthetic adhesives.

The gesso layer smooths out the irregularities in the support; it is usually applied in many thin layers and sanded and polished between applications. The final smooth surface provides an optimum base for painting in a variety of MEDIA. See also GROUND.

GILDING

The technique of affixing very thin sheets of metal called *leaf* to a surface. For the backgrounds of religious PANEL paintings as well as for FRAMES, gold leaf was most often used, but artists and framemakers have also employed silver, tin, aluminum, and other metals. The oldest and most common method is water gilding, in which the surface is prepared with a coating of BOLE, a mixture of red clay and a water-based binder. Once set, the bole is wetted, reactivating the binder, and the leaf adheres to it as soon as it is placed in proximity. When the whole surface is covered, the leaf can be burnished to a brilliant metallic finish with polished mineral or bone. Mordant gilding, the other principal method, is achieved by applying an adhesive (mordant) to any surface. When it is dry enough to be sufficiently tacky, the leaf is laid on. This method differs from water gilding principally in that it cannot be burnished. Mordant gilding was primarily used in painting not to produce a ground but rather to add linear decoration in metal to the painted surface, usually to imitate gold cloth or metallic embroidery on drapery. The adhesive could be applied selectively to the painted surface in any pattern desired and the leaf would stick only to those areas. Powdered gold mixed with a binder was later used to apply linear decoration. It is called shell gold because of the containers in which it was mixed.

An example of gilding can be seen in the illustration accompanying TRIPTYCH. For another technique used to create gold cloth, see SGRAFFITO.

GLASS

Because of its fragility, glass has only occasionally been used as a SUPPORT for OIL or GOUACHE, chiefly in the eighteenth and nineteenth centuries. Usually the pane was intended to be viewed from the unpainted side, often via transmitted light as in a stained-glass window. To investigate light effects in landscape

painting, Thomas Gainsborough painted such "transparencies," which were displayed in a peep-show, a simple wooden box with an eyehole through which the spectator could view the painted glass illuminated by candles from behind. In the twentieth century, the Blaue Reiter group of Expressionist artists produced notable paintings on glass.

GLAZE A transparent layer of darker paint that is applied over an opaque layer of lighter paint. Glazes may also be applied on top of one another as a means of creating a sense of depth and translucency.

Although glazes can theoretically be made with all paint MEDIA, they are most commonly associated with OIL paintings. The rich, translucent nature of oil paint, which can be mixed with resins in order to facilitate the handling and transparency of the paint, lends itself to glazing techniques. (Illustration on next page.)

GLUE TEMPERA

See TEMPERA.

GOUACHE

An opaque, matte, water-based paint made from gum arabic and
a chalk-like filler. The term *gouache* can refer both to the paint
MEDIUM as well as to the technique of using WATERCOLORS (which
are also made from gum arabic) in an opaque fashion. See also
CARTOON and its accompanying illustration.

GRISAILLE

A French term for monochrome painting in shades of gray. The
technique was used by painters in OIL SKETCHES to examine the
overall balance between light and shade in a composition; in
the creation of UNDERPAINTING for a full-color painting; and in
the simulation of sculpture or relief in independent compositions.

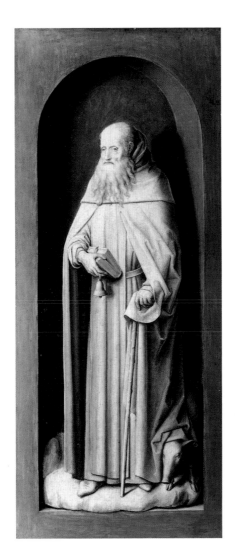

GRISAILLE

Hans Memling
(German, active 1465–
d. 1491). *Saint Anthony
Abbot*, c. 1477 (exterior
wing of *"The Donne
Triptych"*). Oil on oak
panel, 71×30.5 cm
(28×12 in.). NGL, 6275.

GROUND

The material applied to a SUPPORT in order to prepare it for
painting. The term can be synonymous with the word *priming*.
Different types of grounds can be loosely associated with different
periods and schools of painting. In Northern European Renais-
sance painting, for example, grounds were traditionally made
from mixtures of chalk (calcium carbonate) and rabbit-skin glue;
in Italy during the same period, gypsum (calcium sulphate) was
used. Venetian painters of the Renaissance favored red grounds;
this practice eventually led to the wide use of a variety of ground
colors, including dark earth tones, blacks, and even rich grays
created by scraping paint residues from a PALETTE and mixing
them with other ground materials. Grounds of lead white and OIL
were popular during the late eighteenth and nineteenth centuries.

HALF-TONE	See COLOR.
HANDLING	See BRUSHWORK.
HORIZON LINE	See PERSPECTIVE.
HUE	See COLOR.

ICONOGRAPHY

The investigation and interpretation of subject matter in the visual arts. The term was first applied to collections of portraits, notably one of famous contemporaries that was assembled by Anthony van Dyck. Today, the word is more commonly used to signify the branch of art history that studies the development of images and symbols, particularly as they relate to the meaning of an individual work in its historical context.

ILLUSIONISM

The creation of an illusion of reality in painting. Through the virtuoso depiction of nature and the manipulation of pictorial techniques such as PERSPECTIVE and FORESHORTENING, the illusionistic painter can convince the eye that what it sees is real. The French term *trompe l'oeil* (fools the eye) is often applied to a painting or a detail in a painting that is intended to deceive and astonish with its realism. There are a number of illusionistic tricks that the painter can employ, such as highly realistic flies painted on fruit, or dew on flowers (see, for instance, the illustration accompanying FUGITIVE PIGMENT). Artists who create murals to look like tapestries might add wrinkles and tears, and painters have often created illusionistic architecture to smooth the transition between actual and fictive reality. Scientific perspective was fully achieved in the fifteenth and sixteenth centuries, and it was rigorously applied in the illusionistic extension of whole rooms through painted architecture, a practice known as *quadratura*. During the Baroque period, the great age of illusionism, painting was combined with real sculpture and architecture to create illusions of unprecedented believability, particularly in ceilings bearing images of heaven. Also in this period, painters created small-scale illusionistic marvels, like the Dutch peep-show cabinets. The illusionistic paintings on the insides of these boxes are viewed through an eyehole and convey the impression of looking into a microcosm of everyday reality.

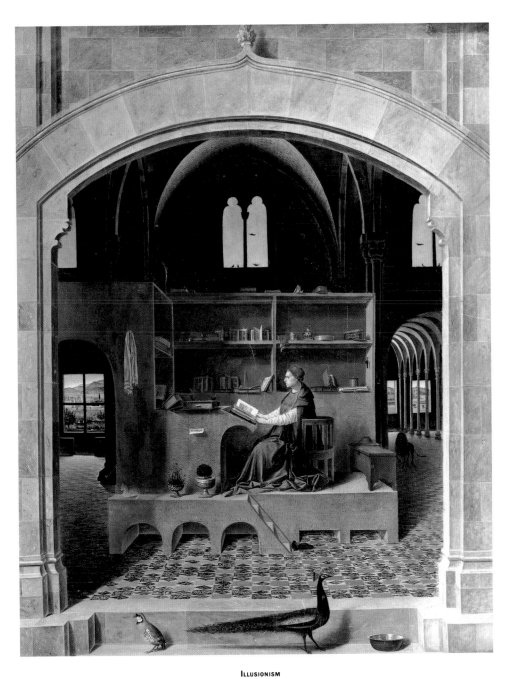

ILLUSIONISM

Antonello da Messina (Italian, active 1456–d. 1479). *Saint Jerome in His Study*, c. 1456.
Oil on limewood panel, 45.7 × 36.2 cm (18 × 14¼ in.). NGL, 1418.

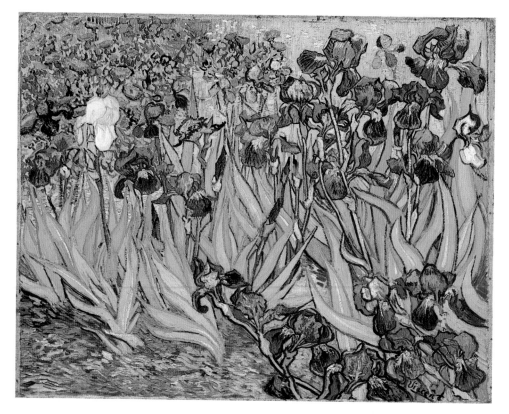

IMPASTO

Vincent van Gogh (Dutch, 1853–1890). *Irises*, 1889. Oil on canvas, 71×93 cm (28×36⅝ in.). JPGM, 90.PA.20.

IMPASTO

The texture created in a paint surface by the movement of the BRUSH. Impasto usually implies thick, heavy BRUSHWORK, but the term also refers to the crisp, delicate textures found in smoother paint surfaces.

IMPRIMATURA

A thin, transparent GLAZE of color applied to a GROUND before painting on it. This preliminary coat not only reduces absorbency but can also be used as a MIDDLE TONE for the painting.

INCISING

An artist may lay out a composition on the GROUND (prior to painting) with the use of a sharp instrument that carves (or incises) lines into the prepared SUPPORT. These lines may remain visible after completion of the painting as slight hollows in the paint. While the technique was sometimes used freehand, incising was most often employed to transfer a design from a CARTOON. Lines

The strength of van Gogh's brushwork is evident in the impasto seen in this detail from the lower right corner of the painting.

were incised with a stylus through the paper cartoon to the support below.

A modern examination technique for studying UNDERDRAWINGS that makes use of a television camera containing an infrared-sensitive tube. The method has been particularly useful in the study of preparatory drawings in Northern European Renaissance PANEL paintings.

Underdrawing materials (such as charcoal or graphite) reflect light in the infrared range. When a painting is studied with an infrared camera, areas of the paint layer that do not reflect light in the infrared range become transparent, and the camera reveals

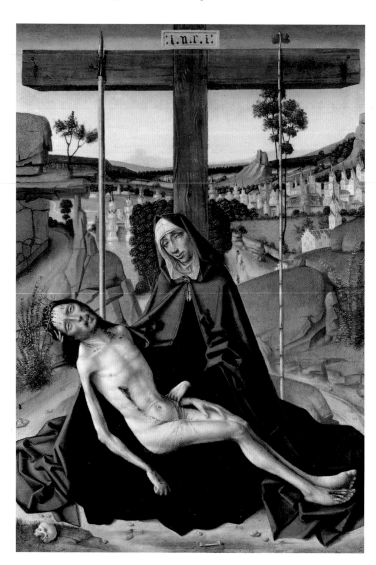

INFRARED REFLECTOGRAPHY
Circle of Fernando
Gallego (Spanish,
c. 1440–after 1507).
The Pietà, c. 1490–1500.
Oil on panel,
49.8 × 34.3 cm
(19⁹⁄₁₆ × 13½ in.).
JPGM, 85.PB.267.

The painting is seen here
in normal light.

the infrared reflective underdrawing; the image can be transferred to a television monitor for viewing. Individual details can be photographed from the monitor and assembled as a mosaic; the resultant image is called a *reflectogram*.

Before the advent of infrared reflectography, paintings were photographed with infrared-sensitive film in order to study underdrawings. However, this technique did not yield as much information as the image associated with the more sophisticated video system.

Studies of underdrawing not only can tell us a great deal about an artist's technique but can also play a role in solving problems of ATTRIBUTION.

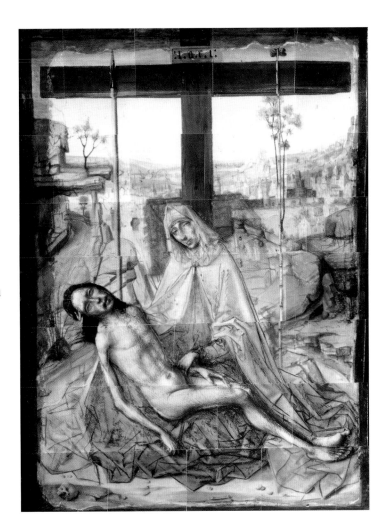

In this infrared reflectogram of *The Pietà*, the underdrawing is visible, particularly in the drapery of the Virgin and in the body of Christ.

INPAINTING	See RETOUCHING.
INSCRIPTION	Other than as a SIGNATURE, the written word is incorporated in paintings most often to identify or comment on the subject(s), whether sitters in portraits or figures in complex religious, mythological, or allegorical compositions. Most inscriptions are made of simple, flat characters painted on a neutral background either by the artist or some later hand. However, inscriptions may also be incorporated illusionistically into paintings in order to appear as if chiseled in stone or written on paper. One favorite device has been the banderole, a scroll or ribbon that appears to float in the air or be draped within the composition.

LINEN　　　　　　　See CANVAS.

LINING　　　　　　A new piece of fabric attached to the reverse of a CANVAS painting
that provides additional support for the picture. Relining implies
removal of an old lining canvas (and adhesive), followed by
replacement with new lining materials.

During the nineteenth century, lining techniques that made
use of starch paste or animal-glue adhesives were developed as a
means of bonding a new piece of linen to the reverse of a painting.
Moisture, heat, and pressure (from heavy irons) were used to
relax distortions in both the paint film and the original canvas and
to activate the adhesive. In the early decades of the twentieth
century, glue or paste linings continued to be popular, but a
variety of new adhesives were later introduced, including mixtures
of beeswax and resin.

Many lining adhesives and techniques were designed not only
to attach the new canvas to the reverse of the original but also to
treat problems on the surface of the picture through impregnation
of the entire structure of the painting. Although this was occa-
sionally desirable, particularly if the paint film was in need of
extensive consolidation in order to prevent further flaking or
decay, such treatments have come to be less favored because of
their invasive qualities. Conservators have come to value the
untouched nature of unlined paintings and have developed new
methods and materials that allow for treatment of structural
problems without altering the appearance or character of the
painting as a whole. As an alternative to lining, treatments of
distortions in the original canvas or flaking of the paint surface
can be made separately, and the painting can be restretched
directly over a new, but unattached, piece of fabric, a technique
called *loose lining*. The term *strip lining* refers to the practice
of reinforcing the tacking edges of a painting with new strips of
fabric, thus allowing for improved restretching of the canvas.
When lining is absolutely necessary, due to the degradation of the
original support or the sheer weight of the paint film, many new
non-invasive synthetic adhesives and fabrics have been introduced
that allow for the use of minimal heat and pressure.

LUNETTE

A semicircular painting, often created to be displayed over a door or a window with a vault above it. Lunettes also appear at the tops of some altarpieces.

MANNER OF

See ATTRIBUTION.

MEDIUM (pl. MEDIA)

The material that is mixed with raw PIGMENTS in order to create paint. The medium (or vehicle) is ultimately the material that binds the pigments to the SUPPORT. See also ACRYLIC, CASEIN, ENCAUSTIC, GOUACHE, OIL, TEMPERA, and WATERCOLOR.

MIDDLE TONE

See COLOR.

MIXED TECHNIQUE

The use of at least two different types of MEDIA within the same painting. In early Italian paintings, for example, the term refers to the practice of applying translucent, OIL-resin–based glazes on top of the more opaque egg-TEMPERA UNDERPAINT. In later painting, the term also implies the use of an emulsified medium in which two distinctly different media (such as egg tempera and oil) have been combined into a single paint mixture.

Modeling

The representation of a three-dimensional form on a two-dimensional surface, usually achieved through the variation of light and shadow across the depicted form. This modulation of light makes the form appear solid, round, and palpable. The term *plasticity* refers to the three-dimensional quality of fully modeled figures or objects. For forms modeled with an extreme contrast between light and dark, see CHIAROSCURO; for those shaped with subtle gradations of light, see SFUMATO.

MODELLO See OIL SKETCH.

MURAL A painting executed directly on or permanently affixed to a wall. The term is used synonymously with *wall painting*. See also FRESCO.

OIL The general term that describes a drying oil used as a paint MEDIUM. Oil commonly implies the use of linseed oil, but it can also refer to several other drying oils: walnut oil, for example, which was used in early Italian painting, or poppyseed oil, which was a favorite of French eighteenth-century painters.

Drying oils are different from nondrying oils (such as olive oil or sunflower oil) because of their unique ability to form solid films upon prolonged exposure to air. The rich, luminous nature and appearance of oils led to their use as paint media.

The use of oils as binders for pigments in paintings can be traced back to the fifth and sixth centuries. (Prior to this time, ancient references to oils only discussed their use in association with cooking, cosmetics, or medicines.) In the early Renaissance, oils were used in combination with other paint media, particularly in transparent GLAZES on egg-TEMPERA paintings. During the fifteenth century, the techniques of oil painting were developed and refined (particularly in Northern Europe, by artists such as the van Eycks), and by the beginning of the sixteenth century oil had become the predominant painting medium.

OIL SKETCH Originally a preparatory study in oils for another work, not necessarily in the same medium (e.g., prints, sculpture, architecture). In the late eighteenth century, painters began making such small-scale, seemingly spontaneous pictures, particularly of landscapes, as independent works of art and not in preparation for more elaborate compositions. See also PLEIN AIR.

Functionally related to drawing, oil sketches were pioneered by sixteenth-century Italian painters. Usually executed on PANEL or CANVAS, but also sometimes on paper (often laid down on canvas or board), these sketches can be painted in monochrome, like GRISAILLE, or they can be fully colored. An oil sketch with particularly sketchy execution that records the painter's early ideas is sometimes called a *bozzetto*. The term *oil sketch* also encompasses the more finished *modello*, a scale model of the final composition meant for presentation to a patron for approval or for use in the artist's workshop in the preparation of a full-scale painting. A *ricordo* is a small oil sketch of a previously executed composition, made as a record by the artist or an assistant.

OIL SKETCH

Peter Paul Rubens (Flemish, 1577–1640). *The Miracles of Saint Francis of Paola*, c. 1627/28.
Oil on panel, 97.5 × 77 cm (38⅜ × 30⁵⁄₁₆ in.). JPGM, 91.PB.50.

Peter Paul Rubens is especially well known for having used assistants to execute his ideas based upon his prepared sketches. He is credited with raising the oil sketch from the level of a mere preliminary exercise to that of an independent work of art.

ORIGINAL

Commonly used to refer to any painting executed entirely by an artist, although more precisely indicating the first example of a painted composition subsequently repeated by the artist or by others. Before the invention of photography, painters were often called upon to reproduce their most popular works. An exact duplicate is called a *replica*. Replicas were often produced by assistants working under the artist's supervision, but when produced by the author of the original, the terms *autograph replica* or *autograph copy* are employed. Used by itself, the term *copy* generally refers to a reproduction by a painter not connected with the WORKSHOP of the original artist. Although the use of the terminology is hardly precise, the terms *version* and *variant* usually refer to compositions produced by the artist or the artist's workshop that alter the appearance of the original; such paintings sometimes bear only a slight resemblance to the original.

OVERDOOR

A painting specially created to hang over a door, often with the PERSPECTIVE adjusted to compensate for its position high above eye level. Overdoors were sometimes painted on SUPPORTS of irregular shape to fit in FRAMES that were part of the architectural decor. See also LUNETTE.

PAINTERLY

See BRUSHWORK.

PALETTE

A support for laying out paint. Many palettes are small enough to be held in the hand (thus the classic thumbhole associated with palette designs), although they can come in almost any size and shape. Palettes can be made from any type of nonabsorbent material; wood is the traditional choice, but ceramics, metals, marble, and glass are also favored.

The term also refers to the general COLOR tonality of a painting. If, for example, the colors within a painting are predominantly blue, the effect is that of a "cool palette"; on the other hand, red tones result in a "warm palette."

PALETTE KNIFE A flat metal spatula that was originally designed for mixing pigments with a painting MEDIUM. Palette knives were eventually used, in addition to BRUSHES, as a means of applying the paint to the SUPPORT.

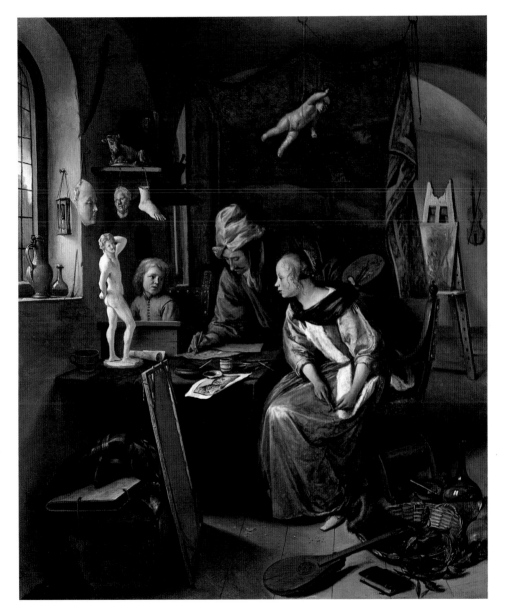

PALETTE

Jan Steen (Dutch, 1625/26–1679). *The Drawing Lesson*, c. 1665. Oil on panel, 49.3 × 41 cm (19⅜ × 16⅛ in.). JPGM, 83.PB.388.
The artist is holding a palette and brushes in his left hand.

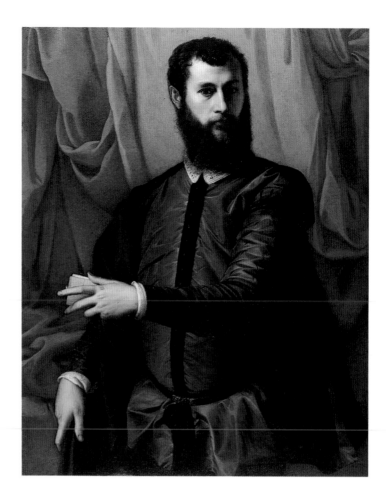

PANEL

A wooden SUPPORT used for a painting. Wood panels were among the earliest types of painting supports; wall paintings (the predominant form of painted decoration in ancient times) were permanent, stationary artworks, whereas use of a wood panel allowed for portability of the work of art. Wood planks could be joined together to create a support of any size or shape.

Nearly all types of wood have been used at one time or another as painting supports. A few broad generalizations can be drawn regarding the popularity of certain types of woods during particular periods. It is generally acknowledged, for example, that Italian painters of the Renaissance used poplar, whereas Northern European painters favored oak. However, the use of such diverse woods as fir, chestnut, walnut, or lindenwood, or such exotic woods as mahogany, was not unusual.

PASTICHE

See FAKES AND FORGERIES.

This beautifully preserved poplar panel still retains the original horizontal battens used to reinforce the support of Salviati's painting.

PENDANT

A painting created as a companion piece to another painting, usually of the same size and with complementary subject and composition. For instance, pairs of portraits were often commissioned by couples, sometimes to celebrate their marriage.

PENTIMENTO

An artist's alteration (literally, repentance or change of mind) that has become increasingly apparent with time. As an artist develops a painting, she or he may choose to alter the placement of particular elements within the composition. Although these changes are initially invisible on the finished surface of the painting, they can become visible over time, emerging as ghost-like images. This is the result of the fact that paint (in particular, OIL paint) tends to become more transparent as it ages; changes lying below the surface will become more evident as the transparency increases.

Pentimenti, like CRAQUELURE, are valued aspects of older paintings. They can provide us with a fascinating glimpse of the artist's mind at work.

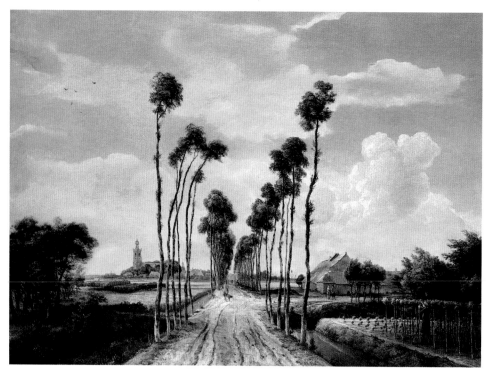

PERSPECTIVE

Meyndert Hobbema (Dutch, 1638–1709). *The Avenue: Middelharnis*, 1689.
Oil on canvas, 103.5 × 141 cm (40¾ × 55½ in.). NGL, 830.

PERSPECTIVE The techniques of representing three-dimensional space on a two-dimensional surface. Overlapping is the simplest and most ancient form of perspective. Before the Renaissance, painters intuitively developed perspective techniques by observing optical phenomena such as the effect of distance on the apparent size of objects. Systematic perspective based on mathematical principles, usually called *linear perspective*, was developed in Italy in the early fifteenth century, as artists sought to represent space with greater naturalism. It is based on the eye's perception that parallel lines converge as they recede from the spectator. In early one-point perspective, all lines except those parallel to the PICTURE PLANE converge toward a single point on the horizon line called the *vanishing point*. Later, artists plotted more than one vanishing point to achieve greater verisimilitude.

Aerial perspective is a nonlinear means of producing a sense of depth in painting. Also called *atmospheric perspective*, it depends on the optical effects of moisture and dust particles in the earth's atmosphere, which make distant objects appear muted and

blue. Thus, to represent distance, painters learned to use a blue haze that subtly mutes other colors toward the horizon. In Italy, Leonardo da Vinci applied his scientific studies of aerial perspective to his paintings. (See the illustration accompanying SFUMATO.)

PICTURE PLANE

The plane separating the imaginary space of a painting and the real space of the spectator. Corresponding to the physical surface of the painting, the picture plane is often likened to a glass window through which an imaginary space is revealed through PERSPECTIVE and FORESHORTENING. With trompe l'oeil ILLUSIONISM, objects are sometimes painted so that they appear to project through the picture plane and into real space and time.

PIGMENT

The coloring agent that is mixed with a binding MEDIUM to form paint. Pigments were originally made from clays (which could be baked or ground into fine powders, such as yellow ocher), ground minerals (such as lapis lazuli, which, when ground into a powder, produces the pigment known as ultramarine blue), and naturally occurring by-products (such as candle soot, used to make lampblack). Synthetic pigments (which are man-made) can also be traced back to ancient times: Egyptian blue, for example, was manufactured from a combination of copper, calcium, and sand (silica). In modern times, less expensive synthetic substitutes have replaced most naturally occurring pigments.

The advent of scientific examination techniques has enabled conservation scientists to identify nearly all of the pigments used in the history of painting; this has led to the discovery that different pigments were used at different points in time. As a result, pigment identification can often be used to support or refute opinions concerning the date and origin of a particular painting. See also FAKES AND FORGERIES.

PINXIT

See SIGNATURE.

PLASTICITY

See MODELING.

PLEIN AIR

The French term meaning "open air" describes the practice of painting outdoors to capture fleeting effects of light and atmosphere. While strictly employed for paintings actually executed outside, the term is also used for a work strongly conveying an impression of nature. Thus, it may be applied to earlier landscape artists who did not habitually paint directly from nature, but it is more usually associated with late-eighteenth- and nineteenth-

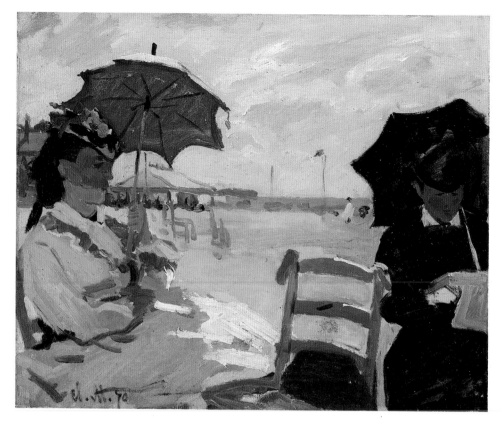

PLEIN AIR

Claude-Oscar Monet (French, 1840–1926). *The Beach at Trouville*. Signed and dated: *Cl.M.70*.
Oil on canvas, 37.5×45.7 cm (14¾×18 in.). NGL, 3951.
In this *plein air* painting, particles of sand and shell from the beach are imbedded in the paint surface.

century painters, especially the Barbizon School and the
Impressionists.

POLYPTYCH

A painting comprising four or more panels, usually an altarpiece,
whether hinged together or arranged in a fixed architectural
FRAME. A typical form consists of a principal central image flanked
by side panels, with subsidiary rows or registers of panels above
and below. The lower register is called the *predella* and is composed
of smaller panels, often with narrative episodes from the lives of
the saints depicted above. (See the illustration accompanying
FRAME.) See also DIPTYCH and TRIPTYCH.

POUNCING

A method of transferring a design from a CARTOON to the surface
of a CANVAS, PANEL, or FRESCO. Holes are pricked along the

outlines of the original design, which is then placed over the surface to be painted. Pounce, a fine powder of charcoal, chalk, or clay, is then dusted through the holes to mark the surface below. The technique was used for transferring whole compositions but was particularly useful for repetitive design passages, for which stencils were employed. Pounce marks can sometimes be seen on the surfaces of paintings and, if made with charcoal, such marks can be detected with INFRARED REFLECTOGRAPHY. For other transfer techniques, see INCISING and SQUARING.

PREDELLA See POLYPTYCH.

PRIMING See GROUND.

PROVENANCE The history of the ownership of a work of art. It is sometimes possible to trace paintings all the way back to the artist's studio, especially when the work gained immediate fame or was commissioned by an important patron. With other pictures, painstaking research is required. In addition to information provided by present and past owners, the tools of provenance include contemporary descriptions, inventories of collections, inventory numbers on the paintings themselves, and auction sales catalogues.

PUNCHMARK See TOOLING.

QUADRATURA See ILLUSIONISM.

RELINING See LINING.

REPLICA See ORIGINAL.

RESTORATION See CONSERVATION.

RETOUCHING This term originally referred to corrections or additions made by an artist as final adjustments to a completed picture. However, the term has come to identify something quite different: the work done by a restorer to replace areas of loss or damage in a painting. In the past, retouches often covered broad areas of the original painting; contemporary CONSERVATION ethics dictate that retouching (or "inpainting") must be confined to the areas of loss. Retouches are executed in a MEDIUM that differs from the original so that they can be removed easily; OIL paintings, for example, can be retouched with materials such as WATERCOLORS or synthetic resin-based paints.

Retouching is usually intended to remain invisible to the

naked eye. Examination of a painting under ULTRAVIOLET light will usually reveal the presence of retouching; photographs are used by conservators to document paintings in their unretouched (or cleaned) state, and these also provide a clear record of areas that have been subsequently inpainted.

Not all retouches are intended to completely disguise the losses within a painting. Different philosophies of restoration promote different approaches to retouching. The most familiar variant is *tratteggio*, a method developed in Italy and based upon filling in the loss with many vertical, parallel strokes of paint (usually watercolor). In principle, this type of retouching is visible when the painting is examined at close range but blends in discreetly with the original at a normal viewing distance. Other

RETOUCHING

Vittore Carpaccio (Italian, 1455/56–1525/26). *Hunting on the Lagoon*, c. 1490/96. Oil on panel, 76 × 63.8 cm (30 × 25⅛ in.). JPGM, 79.PB.72.

The painting is seen here in its cleaned state before retouching.

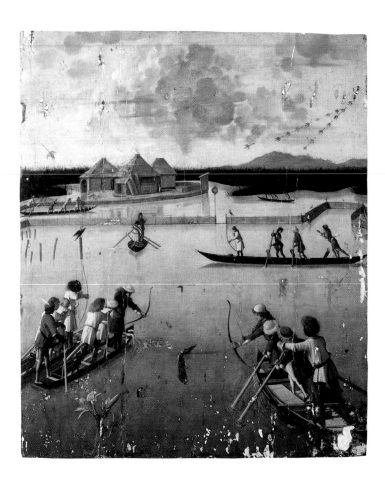

variations on this type of retouching include the method of *integrazione cromatica* (in which an abstract pattern of overlapping strokes, drawn from the colors used in the original painting, is used to fill in the loss) and so-called "neutral" retouches (which derive from a purist belief in the need to leave all of the damage visible on the surface).

Very few paintings have survived without incurring some sort of damage to their surfaces. Retouching, therefore, is to be expected. If it is skillfully executed, retouching will not interfere with the viewer's experience of the work of art and will have little effect upon the intrinsic value of the painting.

SCHOOL OF See ATTRIBUTION.

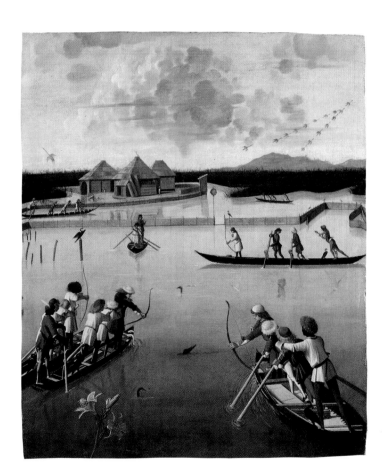

The losses and damages to Carpaccio's painting have been completely retouched.

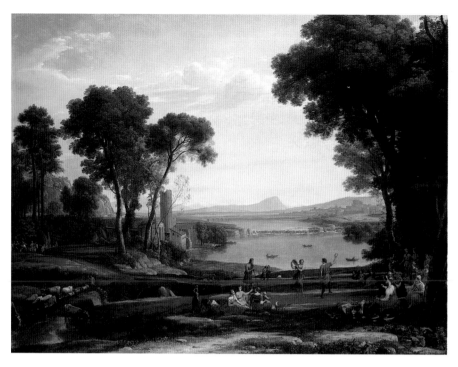

Claude Lorrain (Claude Gellée [French, 1600–1682]). *Landscape: The Marriage of Isaac and Rebekah ("The Mill"),*
1648. Oil on canvas, 149.2 × 196.9 cm (58¾ × 77½ in.). NGL, 12.
Claude used layers of scumbles to create an illusion of depth in the cool tonalities of his skies.

Scumble	A thin, lighter layer of color placed over a darker UNDERPAINT. In principle, scumbles are the reverse of GLAZES; whereas glazes are dark and transparent, scumbles are light and opaque. The presence of the darker underlayer will, as a rule, shift the appearance of the scumble toward a blue or cooler tone.
Sfumato	The imperceptible gradation of tones or colors from light to dark in MODELING, often giving forms soft contours. The early development of the technique is tied to the naturalistic goals of the Renaissance. It is particularly associated with the paintings of Leonardo da Vinci, who wrote that light and shade should blend "in the manner of smoke" (*fumo*).
Sgraffito	An Italian word meaning "scratched," used to describe a method of attaining effects, like gold cloth, with metallic leaf in a painting. Following GILDING, the metallic surface was painted over. Once dry, the paint surface could be scratched through to reveal the gold beneath.

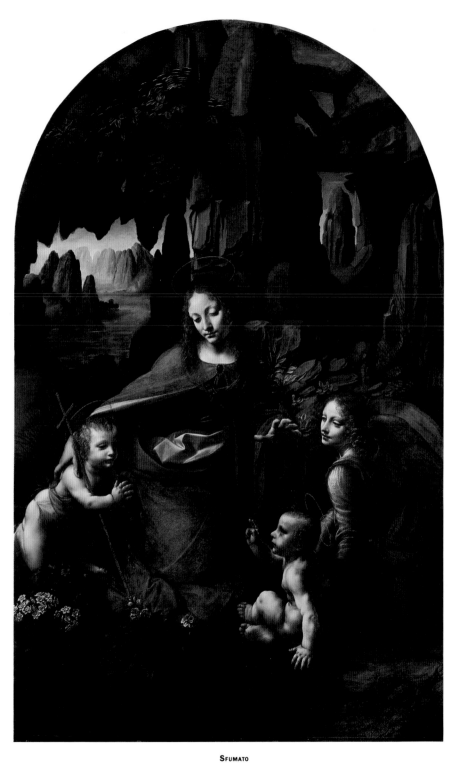

SFUMATO

Leonardo da Vinci (Italian, 1452–1519). *The Virgin of the Rocks*, 1483–1506.
Oil on panel, 189.5 × 120 cm (74⅝ × 47¼ in.). NGL, 1093.

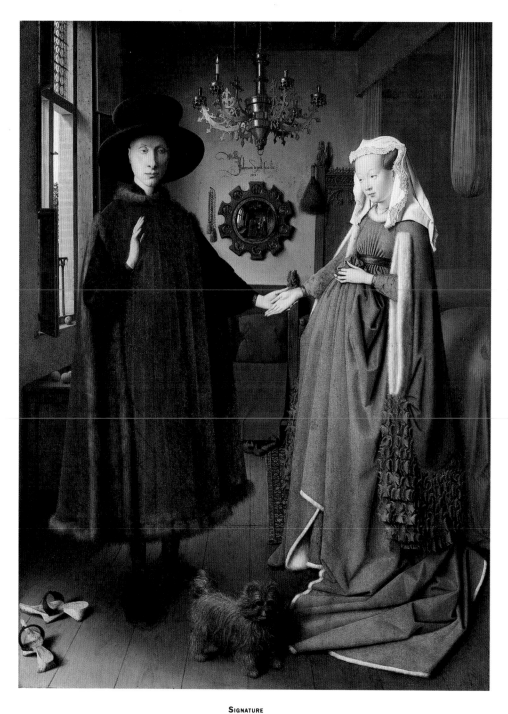

SIGNATURE

Jan van Eyck (Netherlandish, active 1422–d. 1441).
"The Arnolfini Marriage": Double Portrait of Giovanni di Arrigo Arnolfini and His Wife Giovanna, 1434.
Oil on oak panel, 81.8 × 59.7 cm (32¼ × 23½ in.). NGL, 186.

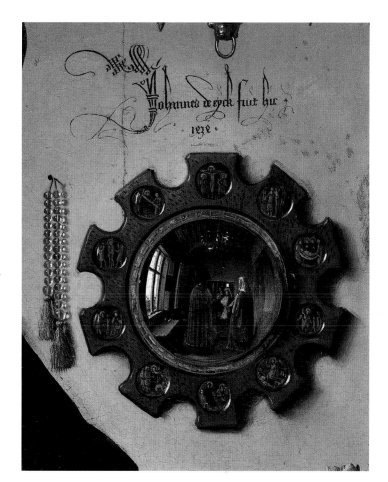

The signature and inscription read: *Johannes de eyck fuit hic. 1434* ("Jan van Eyck was here, 1434"). The reflection visible in the mirror shows the painter and is a masterful example of ILLUSIONISM.

SIGNATURE

While some painters habitually autograph their works, others never do. Although usually a matter of personal preference, some contracts specify that the artist should sign the work, especially if he or she has already achieved fame. There are many styles of signatures, varying from true autographs to complex lettering schemes. Some painters include their full name, while others, like Albrecht Dürer, create distinctive monograms. A signature may be included in a much longer INSCRIPTION. The letter *f* following a signature stands for the Latin *fecit*, or "made it," which is sometimes followed by the date. Similarly, *pinxit* means "painted it." Signatures may be inscribed on the PICTURE PLANE or they may be incorporated into the composition as if written on a wall or on a little piece of paper, called a *cartellino* (see the illustration accompanying ATTRIBUTE). A signature alone cannot determine the authenticity of a painting because some artists are known to have signed works executed by others. Likewise, forged signatures are found not only on FAKES but also on authentic works.

Sinopia See FRESCO.

Size In its broadest sense, the term applies to any material used as a primer to seal an absorbent surface. Sizes traditionally are dilute solutions of water-based glues; CANVAS, for example, can be coated with a thin size of gelatin in order to prevent OILS or resins from subsequent GROUND or paint layers from soaking through to the threads of the fabric. Sizing can also be used to stiffen a surface or to produce a smooth finish; GESSO grounds were often sized as part of the final preparation of their surfaces.

Sketch See OIL SKETCH.

Sotto in sù An Italian term meaning "from below upward," used with regard to illusionistic ceiling paintings to describe the extreme FORE-SHORTENING of figures and objects so that they actually seem to exist in the space over the viewer's head. In the first major example of this technique, Andrea Mantegna's ceiling in the Camera Picta (Mantua, Palazzo Ducale), figures seem to look down into the room from a balcony; most Baroque ceiling paintings used the technique to show figures floating in space. See also ILLUSIONISM.

Squaring A method used to transfer a design from a drawing to the GROUND of a painting when the sizes of the two works differ. A grid is applied over the drawing and a series of proportional squares is drawn on the ground. The contents of each square can then be transferred to the ground by enlargement or reduction. For other transfer methods, see CARTOON, INCISING, and POUNCING.

Stippling See BRUSHWORK.

Stretcher A wooden framework for stretching, supporting, and maintaining the tautness of a piece of CANVAS. Early canvas paintings were stretched across a solid PANEL support, but by the seventeenth century the practice of using fixed wooden frameworks (called strainers) as provisional supports had been introduced; the canvas was temporarily laced onto the strainer during execution of the painting. This technique was similar to the stretching method employed by manuscript illuminators in the preparation of vellum (parchment) sheets. Tension could also be maintained in some provisional strainer types by means of adjustable pegs. After completion, the finished work was restretched onto a fixed strainer or an expandable stretcher that corresponded to the dimensions of the painted surface.

STRETCHER

Jacques-Louis David
(French, 1748–1825).
*The Farewell of Telemachus
and Eucharis*, 1818.
Oil on canvas,
87.8 × 103 cm
(34⁹⁄₁₆ × 40⁹⁄₁₆ in.).
JPGM, 87.PA.27.

The original stretcher is
still visible on the reverse
of David's painting. The
design is typical of French
early-nineteenth-century
stretcher design. Keys are
visible in the corners.

The stretchermaker
inscribed *M. David* on the
reverse of the stretcher
in order to indicate its
final destination.

A wide variety of stretcher designs have been developed. Differences in design usually focus upon the types of joins and expansion mechanisms used in the corners of the stretcher system. A stretcher with "keys," for example, makes use of small, triangular pieces of wood that fit into narrow grooves at the corners of the stretcher members; tapping these keys further into the corners will force the stretcher members to expand, thus increasing the amount of tension on the fabric SUPPORT. This type of readjustment is often necessary because canvas supports expand and contract with changes in humidity levels.

STUDIO OF

See ATTRIBUTION.

STUDY

See OIL SKETCH.

STYLE OF

See ATTRIBUTION.

SUPPORT

A material used as the basic underlying structure in the creation of a painting. Traditional supports include PANELS and CANVAS, but unusual materials such as COPPER, GLASS, and slate have also been used. Supports are chosen not only because of their practical characteristics but also because different materials will impart their own qualities to the surface of the painting.

TEMPERA

A water-based paint MEDIUM that, upon drying, produces an opaque surface with a soft sheen. Egg tempera is made primarily from egg yolk (although egg white can be added), and glue tempera (sometimes called *distemper* or, if painted on very fine linen, *Tüchlein*) is made from animal glue.

Egg-tempera techniques were fully developed during the early Italian Renaissance. Although egg was eventually replaced by oil as the predominant painting medium, interest in the use of egg tempera revived during the nineteenth century and has continued to this day. The medium produces a hard, durable, and somewhat lustrous surface. Egg tempera dries very quickly and cannot be brushed uniformly over broad areas; as a result, egg-tempera pictures are painted with repeated brushstrokes, visible as many small hatches on the finished surface.

Glue tempera also dries to a matte surface but is more fragile than egg tempera. It can be brushed on in small strokes, in a fashion similar to egg tempera, but glue tempera lends itself to the covering of broader areas as well. (Illustrations at right and on next page.)

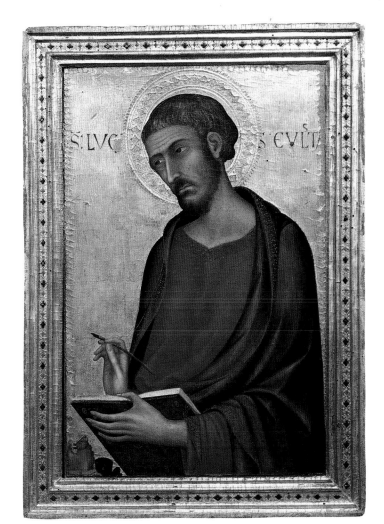

TEMPERA
Simone Martini
(Italian, c. 1284–1344).
Saint Luke the Evangelist,
c. 1330. Egg tempera on
panel, 67.5×48.3 cm
(26⁹⁄₁₆×19 in.).
JPGM, 82.PB.72.

In Simone's egg-tempera
portrait of the patron
saint of painters, the form
has been created by
many parallel strokes of
color.

67

TEMPERA

Dieric Bouts (Flemish, active c. 1445–d. 1475). *The Entombment*, c. 1450/55.
Glue tempera on canvas, 90.2 × 74.3 cm (35½ × 29¼ in.). NGL, 664.
This is a rare example of a *Tüchlein* painting.

TINT

See COLOR.

TONDO

A circular painting, its name deriving from the Italian word for "round." The format became particularly popular in Italy in the last half of the fifteenth century, when many painters took up the challenge of designing appropriate compositions for paintings of this shape.

TONDO

Raphael (Raffaello Sanzio [Italian, 1483–1520]). *The Holy Family with a Palm Tree*, 1490s.
Oil on panel, 101.6 cm (40 in.) in diameter. Duke of Sutherland Collection,
on loan to the National Gallery of Scotland.

TONE

See COLOR.

TOOLING

The ornamentation of the gold GROUND of a PANEL after GILDING and prior to painting. To foster the illusion of a solid gold ground, two metalwork techniques were adapted to make indentations in the thin gold without breaking through to the ground. Lines were incised using a metal stylus or compass to create halos or rays emanating from a saint. To form patterns in borders and backgrounds, punchmarks were made by lightly tapping metal punches with a hammer. For broad areas of pattern, many punches were

used to create complex designs. The incised lines and punchmarks greatly enhanced surface variety by catching the light and making the gold shimmer, but the techniques were also extended to painted areas. Styles of tooling can be quite distinctive and can be used in CONNOISSEURSHIP to associate panels with certain WORK-SHOPS. Sometimes tooling was combined with *pastiglia*, or GESSO molded in relief on the surface of the panel, to enhance the simulation of precious metal.

TOOLING

Gentile da Fabriano (Italian, c. 1370–1427). *The Coronation of the Virgin*, c. 1420.
Tempera on panel, 87.5×64 cm (34½×25³⁄₁₆ in.). JPGM, 77.PB.92.

The process of removing a painting from its original, presumably deteriorated SUPPORT (either CANVAS or wood) and replacing it with a new support. This technique was particularly fashionable during the nineteenth century as a treatment for PANEL paintings, before the advent of environmental controls. Exposure to extreme variations in temperature and humidity, such as dry indoor heat during the winter months, could cause severe splitting and cracking in a panel painting. Theoretically, the painting could be

Incised lines (visible at the top of this detail) create the rays emanating from the dove, and punchmarks form the halos. The Virgin's crown is fashioned of *pastiglia*.

removed from its panel support and placed on a more flexible fabric support. The process involved preliminary application of a protective, reversible facing (made from layers of paper and glue) on the surface of the painting; the wood was then slowly shaved away from the back until the reverse of either the GROUND or the paint film was exposed. A new support of fabric (or wood) was attached by means of adhesives and the protective facing was removed from the surface of the painting.

Transfers were also performed on canvas paintings, if the original fabric had deteriorated irreversibly. In the twentieth century, new panels of laminated synthetic materials have been developed to replace the deteriorated wood or canvas supports.

Successful transfer techniques require exceptional skill on the part of the restorer; in Russia, where the process was popular during the nineteenth century, many of the restorers who completed this somewhat "magical" process were so proud of their work that they would sign the reverse of the transferred painting as a testimony to their skills.

Unfortunately, transfers invariably have a permanent visible effect upon the surface of a painting. Paintings that were originally on wood can develop new (and disturbing) surface textures that result from the weave patterns of the new fabric support. Even if a transfer is executed with extreme care, subtleties in the original handling of the surface of the painting can be distorted and changed. Today, less invasive structural treatments have been developed that have nearly eliminated the need to transfer paintings; sophisticated environmental control systems (which maintain constant levels of temperature and humidity) have also played an instrumental role in preserving original supports.

TRATTEGGIO See RETOUCHING.

TRIPTYCH A picture comprising three panels, usually hinged together. In its most common form, the central panel was twice the width of the outer panels (or wings) so that they could be folded over to close the triptych and protect the images. When made to be closed, the exterior surfaces were also decorated. Like the DIPTYCH, the triptych was a popular form of portable devotional object, but it was also commonly used on a large scale for altarpieces. One standard form employed an image of the Virgin and Child on the central panel, with the donor's patron saints on the wings. See also POLYPTYCH.

TRIPTYCH

Duccio di Buoninsegna
(active 1278–d. 1319).
*The Virgin and Child with
Saints Dominic and Aurea*,
c. 1300. Tempera on
panels, central panel
61.3 × 39 cm (24⅛ × 15⅜
in.); wings 45.3 × 19.7 cm
(17⅘ × 7⅔ in.). NGL, 566.

The gold ground behind
the Virgin and Child
was created with water
GILDING; the gold details
on the Virgin's robe are
examples of mordant
gilding.

TROMPE L'OEIL	See ILLUSIONISM.
TÜCHLEIN	See TEMPERA.
ULTRAVIOLET	Ultraviolet illumination is used as a scientific aid in the examination of paintings. Because different painting materials exhibit characteristic fluorescence colors when exposed to ultraviolet light, ultraviolet illumination can be used to identify areas of RETOUCHING and to determine different types of VARNISH.

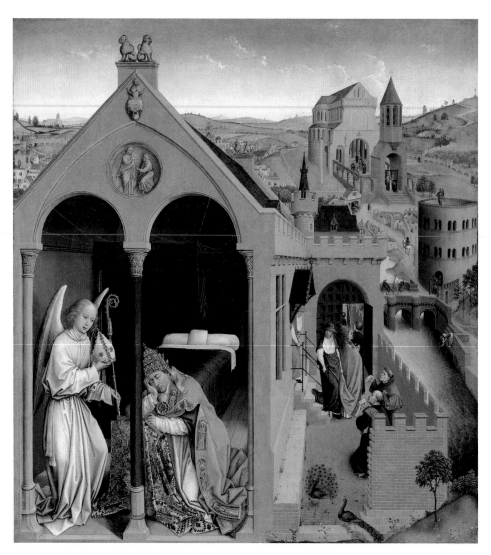

ULTRAVIOLET
Follower of Rogier van der Weyden (Flemish, 1399/1400–1464). *The Dream of Pope Sergius*, c. 1495.
Oil on oak panel, 90.1 × 81.6 cm (35½ × 32⅛ in.). JPGM, 72.PA.70.
The painting is seen here in normal light.

The painting is brought into a darkened room and then lit with ultraviolet light. Areas of recent retouching will often appear as a dark purple, in stark contrast to the lighter, greenish appearance of the older, original paint. Different types of varnish may also exhibit characteristic features under ultraviolet light. (Shellac, for example, fluoresces a bright yellow-orange.) Identification of certain pigments (such as natural madder lakes, which are deep, transparent violet-reds made from natural dyes) can occasionally be made from their individual fluorescence colors.

Ultraviolet illumination of the painting reveals areas of retouching, which fluoresce darker than the original paint. This phenomenon is particularly evident in the sky.

UNDERDRAWING

A preparatory drawing directly on a GROUND, which is subsequently covered with paint. Such drawings are often executed with charcoal, chalk, pencil, or paint and brush. Depending on the artist and the function of the picture, underdrawings can range from quickly sketched outlines to quite detailed renderings. Until recently, this type of drawing was visible to the naked eye primarily in unfinished works or when thin paint layers became more transparent over time. The technique of INFRARED REFLECTOGRAPHY has made it possible to view some underdrawings through the paint layer. The study of the changes made between the drawing and the painted image allows us to observe the creative process of the painter in greater detail than ever before.

UNDERDRAWING
Giovanni Battista Cima da Conegliano (Italian, 1459/60?–1517/18). *The Virgin and Child with Saints* (unfinished), c. 1490. Oil on panel, 47.7 × 39.7 cm (18¾ × 15⅝ in.). Edinburgh, National Gallery of Scotland, 1190.

UNDERPAINTING

A preparatory paint layer applied by the artist as a means of establishing basic areas of light, dark, or COLOR within a composition. Because the appearance of even the most opaque paint MEDIA will be affected by underlying paint layers, underpainting is crucial to the development of a picture and to the character of the finished surface. Underpaints intended to play a major role in the final appearance of the surface may be covered with thin GLAZES or SCUMBLES.

The term *dead coloring* refers to an artist's initial blocking in of broad areas of underpainting.

VALUE

See COLOR.

VANISHING POINT

See PERSPECTIVE.

VARIANT

See ORIGINAL.

VARNISH

A coating applied to the surface of a painting. The varnish layer plays a dual role: it has a profound effect upon the final appearance of the painting and also serves as a protective coating for the paint surface.

The variety of varnishing materials is as diverse as the choices of paint MEDIA and techniques throughout the history of painting. The benefits of using a clear resin as a final coating for a surface were realized during antiquity; waxes, for example, have been found on the surfaces of ancient wall paintings and must have been chosen because they produce a uniform, luminescent sheen on the surface. By the early Renaissance, a variety of materials had been developed for use as painting varnishes, ranging from egg white to sandarac resin (obtained from North African pine trees). Tree resins (such as mastic and dammar), fossil resins (such as copal), and insect excretions (such as shellac) eventually became the types of materials most frequently chosen for use as varnishes. Complicated oil/resin mixtures (made with such drying oils as linseed oil) were also developed as varnishes, although such mixtures are considered undesirable because of their tendency over time to become very discolored and virtually insoluble (making them extremely difficult to remove). Many of these natural materials are still in use today by artists and restorers; numerous synthetic varnishing materials have also been developed that provide a wide array of surface characteristics.

Although varnishes are traditionally clear, they can be toned or altered with the addition of PIGMENTS and other materials. Varnishes also tend to darken and discolor with time, necessitating their removal and replacement. This cleaning process is made

technically possible as a result of the difference in solubility between the soft, easily dissolved varnish and the harder medium of the aged paint film. Many of the recently introduced synthetic varnishes have the added advantage of remaining stable and unchanged in appearance over time. Additives for natural varnishing materials have also been developed to prevent discoloration, thus reducing the need for frequent removal and replacement of varnishes.

On a microscopic level, a varnish coating fills in the tiny gaps and spaces in the upper layer of a paint film, providing a uniform surface for the reflection of light. As a result, the pigments within the painting become deeper, or more saturated, in appearance. Variable aspects of varnishes, such as level of gloss and thickness of coating, are controlled by the artist or restorer. Some paintings (such as Dutch seventeenth-century landscapes) will require highly saturated, rich surfaces, while others (such as Italian egg-TEMPERA paintings) will require a soft matte sheen.

Many paintings are best left without any sort of varnish coating. The Impressionists preferred to leave their paintings unvarnished, as they believed that a resinous coating interfered with the freshness and spontaneity of the paint surface. During the twentieth century, many artists have placed much importance upon small variations in texture and gloss within their paintings; an overall varnish coating would tend to homogenize these fragile surfaces and eliminate such subtle effects.

VEHICLE See MEDIUM.

VERSION See ORIGINAL.

WALL PAINTING See MURAL.

WATERCOLOR In its most general sense, any paint with a water-soluble MEDIUM. However, the term usually refers to a type of painting with translucent washes of pigment suspended in a solution of gum arabic and water on a white or light colored GROUND. Highlights are often attained by thinning the paint with water so that the ground shows through, rather than using an opaque white, as is done with another water-based paint, GOUACHE.

WATERCOLOR
Joseph Mallord William Turner (British, 1775–1851). *Venice: Sunset,* 1840.
Watercolor on paper, 24.1 × 30.2 cm (9½ × 11⅞ in.). London, Tate Gallery, T.B. CCCXVI-25. Photo: John Webb.

WORKSHOP The name of the place where a painter works is also applied to the group of artists, artisans, and apprentices who work for him or her. The successful painter might require a large space and a number of assistants to accommodate the production of many paintings at the same time. The medieval guild's system of apprenticeship established the workshop as a center for the education of the artist. Records of some workshops in the Renaissance and Baroque periods indicate that they functioned as early academies, exploring the boundaries of art. There are also a few tales of prodigies being exploited by their masters.

The quality of paintings produced by workshops has varied greatly depending on the degree of supervision by the artist. Some artists clearly demanded a relatively high level of work from their shop, while others accepted far less. Also, some artists became more involved, RETOUCHING the work of assistants to make it their own. Shop productions were often sold as the master's work because invention was deemed more important

than execution, but the value we attach to ORIGINAL works has long been shared by artists and connoisseurs. Today, when a painting is attributed to the workshop of an artist it usually signifies an unknown contemporary working closely with him or her.

X-RAY

A scientific tool used in the examination of paintings. To create an X-ray image (known as a radiograph), a sheet of X-ray–sensitive film is first placed in contact with the surface of the painting. Low voltage X-rays are generated at an X-ray source and pass through the painting, registering an image that appears on the film after normal photographic development. The image results from the fact that different pigments (which have different densities) will variably affect the quantity of X-rays that are allowed to pass through to the film. The lead in lead white, for example, is a very dense element and will prevent penetration of the X-rays; areas containing lead white will read as lighter regions on the radiograph. Less dense pigments, such as earth tones, allow for the passage of more of the X-rays and will read as darker areas in the radiographic image.

X-rays are very helpful in revealing losses in the original that may not be immediately visible to the naked eye, as well as original changes that may have occurred during the different stages of development of the painting. See also PENTIMENTO.

X-RAY

Henri Rousseau
(French, 1844–1910).
*Un Centenaire de
l'Indépendance*, 1892.
Oil on canvas,
111.2 × 157.7 cm
(43¾ × 62⅛ in.). JPGM,
88.PA.58.

This X-ray reveals that
Rousseau originally
planned to have several
figures seated at the base
of the tree in the lower
left corner of this
painting.

Selected Bibliography

Armenini, Giovanni Battista. *On the True Precepts of the Art of Painting*. Edited and translated by Edward J. Olszewsky. N.p., 1977. A sixteenth-century manual for the painter.

Bomford, David, et al. *Art in the Making: Impressionism*, exh. cat. London, National Gallery, 1990–91. This and the following two entries are the catalogues for groundbreaking, in-depth exhibitions on painting techniques.

———. *Italian Painting Before 1400*, exh. cat. London, National Gallery, 1989.

———. *Rembrandt*, exh. cat. London, National Gallery, 1988–89.

Cennini, Cennino. *The Craftsman's Handbook*. Translated by Daniel V. Thompson, Jr., 1933. Reprint. New York, 1960. A fifteenth-century manual for the painter and gilder.

Doerner, Max. *The Materials of the Artist and Their Use in Painting with Notes on the Techniques of the Old Masters*. Translated by Eugen Neuhaus, 1934. Reprint. New York, 1962. An English translation of Doerner's classic *Malmaterial und seine Verwendung im Bilde*, first published in 1921.

Eastlake, Sir Charles. *Methods and Materials of Painting of the Great Schools and Masters*. New York, 1960. A reprint of *Materials for a History of Oil Painting* (London, 1847–49).

Gettens, Rutherford J., and George L. Stout. *Painting Materials: A Short Encyclopedia*. New York, 1966. The unsurpassed technical study of supports, media, and pigments.

Mayer, Ralph. *The Artist's Handbook of Materials and Techniques*, 4th rev. ed. New York, 1981. A useful reference tool for the contemporary painter, with references to the techniques of the past.

Murray, Peter and Linda. *The Penguin Dictionary of Art and Artists*, 6th ed. London and New York, 1989.

The Oxford Dictionary of Art. Edited by Ian Chilvers and Harold Osborne. Oxford and New York, 1988.

Stout, George L. *The Care of Pictures*, 1948. Reprint. New York, 1975.

Thompson, Daniel V. *The Practice of Tempera Painting*. New York, 1962.

Vasari, Giorgio. *Vasari on Technique*. Translated by Louisa S. Maclehose, edited by G. Baldwin Brown. New York, 1960.

Veliz, Zahira, ed. and trans. *Artists' Techniques in Golden Age Spain: Six Treatises in Translation*. Cambridge and New York, 1986.

Frans van Mieris the Elder (Dutch, 1635–1681). *Pictura (An Allegory of Painting)*, 1661.
Oil on copper, 12.5 × 8.5 cm (5 × 3½ in.). JPGM, 82.PC.136.

John Harris, Editor

Kurt Hauser, Designer

Elizabeth Burke Kahn, Production Coordinator

Charles Passela and Louis Meluso, Photographers

Eileen Delson, Production Artist

Typeset by Wilsted & Taylor, Oakland, California

Printed by L.E.G.O., SpA, Vicenza, Italy